THIEBAUD

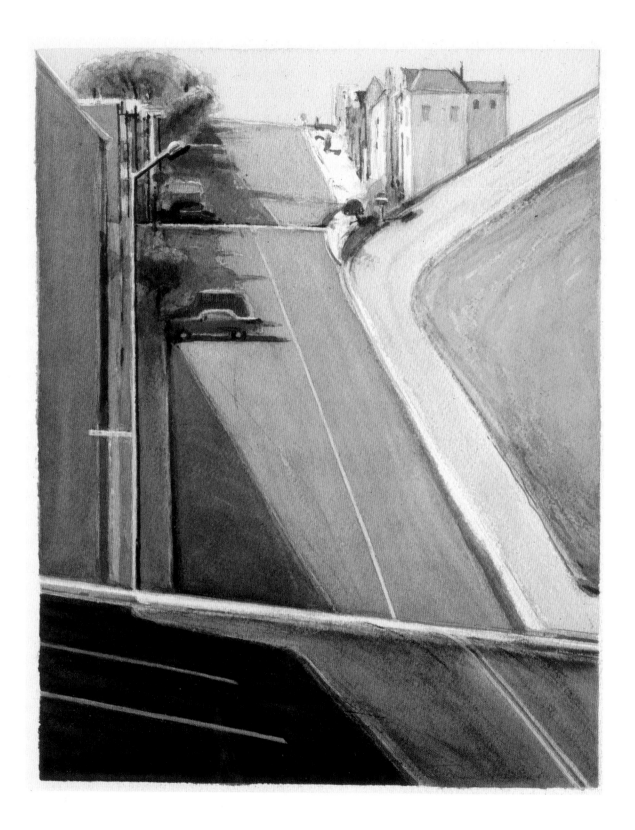

THIEBAUD
delicious metropolis

THE DESSERTS AND URBAN SCENES OF WAYNE THIEBAUD

CHRONICLE BOOKS
SAN FRANCISCO

Previous pages: **Pennsylvania Downgrade,** 1979, watercolor on paper, 10 x 8 in. (25.5 x 20.5 cm)
Neapolitan Pie, 1963–1965, oil on canvas, 17 x 22⅛ in. (43 x 56 cm)

Library of Congress Cataloging-in-Publication Data

Names: Thiebaud, Wayne, artist.
Title: Delicious metropolis : the desserts and urban scenes of Wayne Thiebaud
 / by Wayne Thiebaud.
Description: San Francisco : Chronicle Books, 2019.
Identifiers: LCCN 2018030911 | ISBN 9781452169934 (hardcover : alk. paper)
Subjects: LCSH: Thiebaud, Wayne—Themes, motives.
Classification: LCC ND237.T5515 A4 2019 | DDC 759.13—dc23 LC record available at
https://lccn.loc.gov/2018030911

ISBN: 978-1-4521-6993-4

Manufactured in China.

Designed by Allison Weiner.

10 9 8 7 6 5 4 3 2 1

Chronicle books and gifts are available at special quantity discounts to corporations, professional
associations, literacy programs, and other organizations. For details and discount information, please
contact our premiums department at corporatesales@chroniclebooks.com or at 1-800-759-0190.

Chronicle Books LLC
680 Second Street
San Francisco, California 94107
www.chroniclebooks.com

CONTENTS

Artist's Statement

Wayne Thiebaud

Originally written in 1962 for the Museum of Modern Art, New York, as a part of the museum's accession process

At present I am painting still lifes taken from window displays, store counters, supermarket shelves, and mass produced items from manufacturing concerns in America.

I try to find things to paint which I feel have been overlooked. Maybe a lolli-pop tree has not seemed like a thing worth painting because of its banal ref-erences . . . more likely it has previously been automatically rejected because it is not common enough. We do not wish it to be the object which essentiallizes our time. Each era produces its own still life. Painters use the objects as ele-ments and units of their compositions. It seems to me that we are self-conscious about our still lifes without good reason. It is easier to celebrate the copper pots and clay pipes of Chardin or to pretend that our revolutions are the same as the ones expressed in the apples of Cézanne. We are hesitant to make our own life special . . . set our still lifes aside . . . applaud or criticize what is especially us. We don't want our still lifes to tattle on us. But some years from now our foodstuffs, our pots, our dress, and our ideas will be quite different. So if we sentimentalize or adopt a posture more polite than our own we are not having a real look at ourselves for what we are. My interest in painting is traditional and modest in its aim. I hope that it may allow us to see ourselves looking at ourselves.

The specific esthetic and philosophic problems which fascinate me are:

LIGHT: Today the idea of light is tremendously variable. Strong display lights have been developed which can do all kinds of goofey and wonderful things . . . make an object cast colored shadows, change its local color before your eyes, glow and develop a halo or imbue it with a pulsating effect. Often these things have ten, twenty, or more light sources to heighten them . . . used cars, diamonds, and candied apples are displayed and sold to us in this way. Foods, costume jewelry in cafes and stores are visual feasts for the eyes if they can be captured. The problem of catching some of this keeps me going. I have tried several manners to help me . . . Cubism, Expressionism, Surrealism, and others were studied and used in earlier works. For some years I used metallic paints and metallic leafs in an effort to produce this kind of lively light.

Lately I have used a kind of head on directness, placing the object some-where near the middle of the canvas format in a plain or simple background. This is where I am today. My procedure varies. I have worked from the actual objects, from photos I have taken, com-mercial advertising photographs and from memory. This last method (mem-ory) has been my main model during recent years. Theoretically, I try to work out what is most memorable about the subject at hand and get it down. My time spent as an advertising art director, cartoonist, and illustrator some years ago is partly responsible for the look of some of the things.

SPACE: The tradition of sustaining the picture plane interests me right now. My surfaces are activated and brushed heavily to try and keep them visually available. The heavy linear activity formed by ridges of paint helps to "lock in" the planes and make them "flatter." This is one practical reason for the impasto. There is another I will mention later.

The space inference that I want is one of isolation. Ultra clear, bright, air-conditioned atmosphere that might be sort of stirred up around the objects and echo their presence is what I am for. For this reason uninterrupted single colored backgrounds are used, and this allows the brush marks to be seen more clearly and play their role. This background also suggests a kind of stainless steel, porcelain, enameled, plastic world that interests me now.

COLOR: I don't think I am much of a colorist. My main interest is with contrasts of great intensity. This effect exemplifies the idea of starkness and glare that I am trying for. So I don't think much about color in terms of hue. The real color of the object is paramount in this series, so in my paintings a lemon pie is that yellow, and breads are the closest color to the dough that I can get.

I depend upon a line a great deal. The lines are painted and drawn in several intense hues one over the other to make them as lively and as strong as possible. Later on in the painting I may obliterate them in part or repaint them as needed.

PHILOSOPHIC VIEWPOINT:
Painting a row of cakes the way they are displayed on a lunch counter suggests some rather obvious notions about conformism, mechanized living, and mass produced culture. In addition there are some surprising things which are present . . . how alone these endless rows can be . . . a kind of lonely togetherness . . . each piece of pie has a heightened loneliness of its very own giving it a uniqueness and a specialness in spite of its regimentation. None of us can escape our responsibility however totalitarian or utopian our world may be.

Earlier in this discussion I mentioned the use of impasto in painting this series. This is done for a specific purpose. It alludes to the tradition of illusionistic painting. In my case an experiment with what happens when the relationship between paint and subject matter comes as close together as I can possibly get them . . . white, gooey, shiny, sticky oil paint spread out on the top of a painted cake "becomes" frosting. It is playing with reality . . . making an illusion which grows out of an exploration of the propensities of materials . . . an approach to "actualism." And while it is clearly in the line of "trick-of-the-eye" painting where the artist is like a magician, I would like to show my hand and expose the trick . . . allowing the thrill of self discovery and the ability to see oneself having the illusion.

Of course, I hope that the paintings speak better for themselves than I have.

Two Rows of Cakes, 1963,
brush with black ink and watercolor on paper,
16¾ x 22¼ in. (42.5 x 56.5 cm)

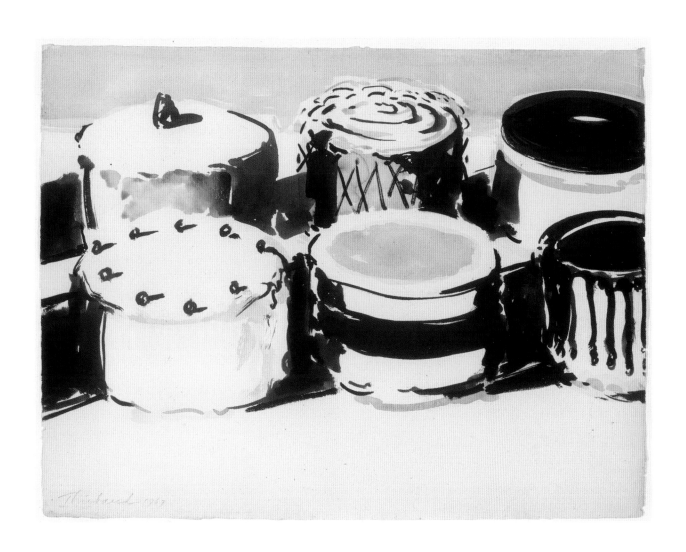

Cake Slices, 1963,
brush with black ink and
watercolor on paper,
20½ x 24½ in. (52 x 62 cm)

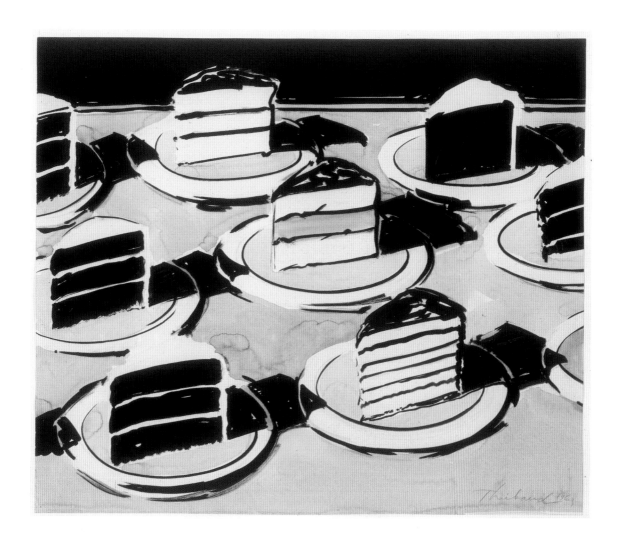

14

Candy Counter, 1966, mixed media on paper, 22 x 30 in. (56 x 76 cm)

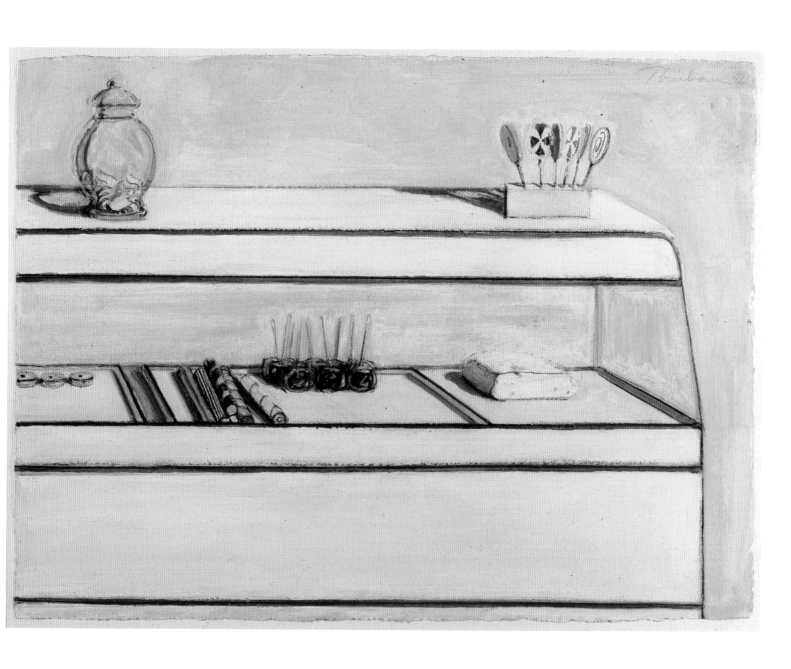

Candy Counter, 1969,
oil on canvas, 47½ x 36⅛ in.
(120.5 x 92 cm)

18

Boston Cremes, 1969,
acrylic and gouache over color reproduction,
14⁷⁄₈ x 20 in. (38 x 51 cm)

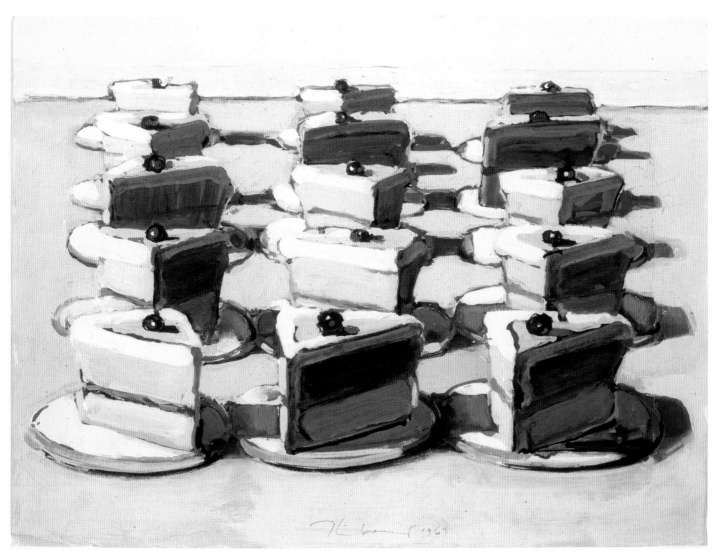

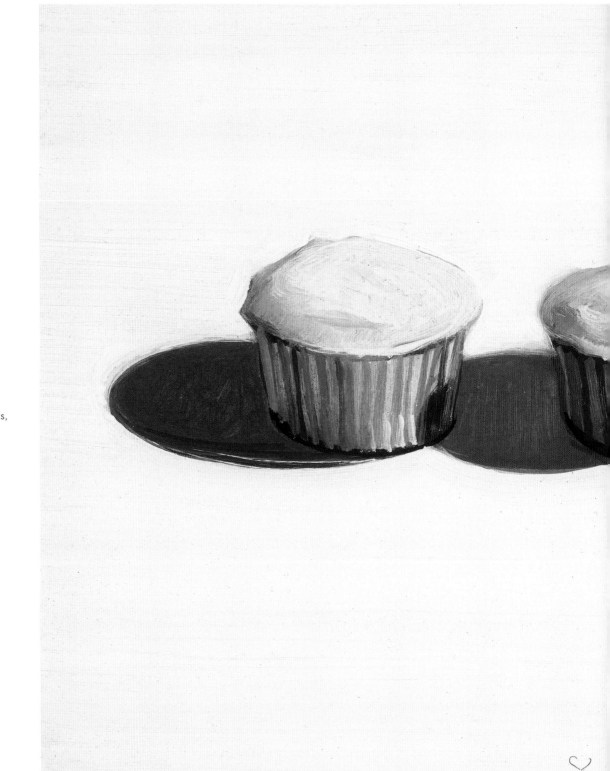

Four Cupcakes, 1971,
oil on paper mounted on canvas,
11 x 19¼ in. (28 x 29 cm)

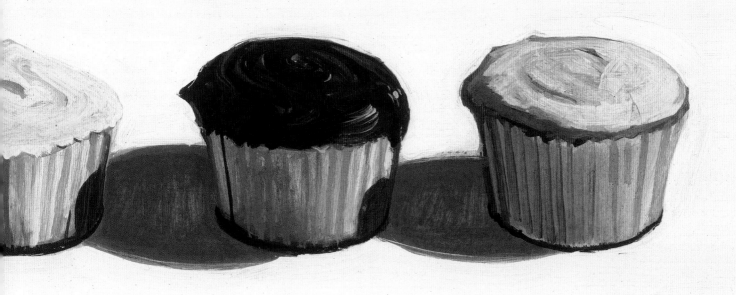

Various Cakes, 1981,
oil on canvas, 25 x 23 in.
(63.5 x 58.5 cm)

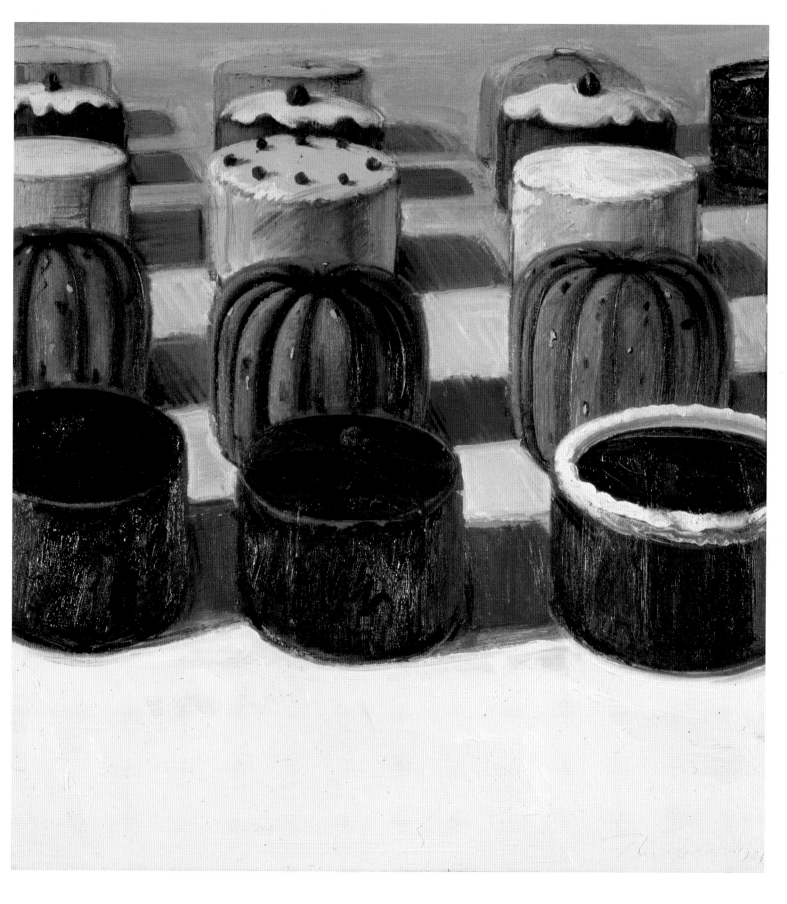

24

Chez Panisse Desserts, 1984,
oil on canvas, 7 x 16 in.
(18 x 40.5 cm)

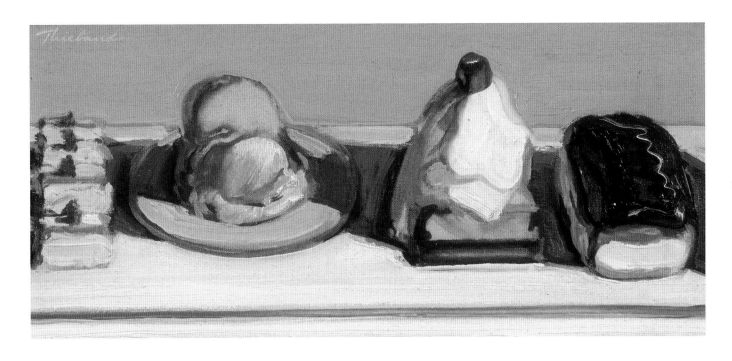

25

Candy Apple, 1991–2002, oil on board, 10½ x 9¼ in. (26.5 x 23.5 cm)

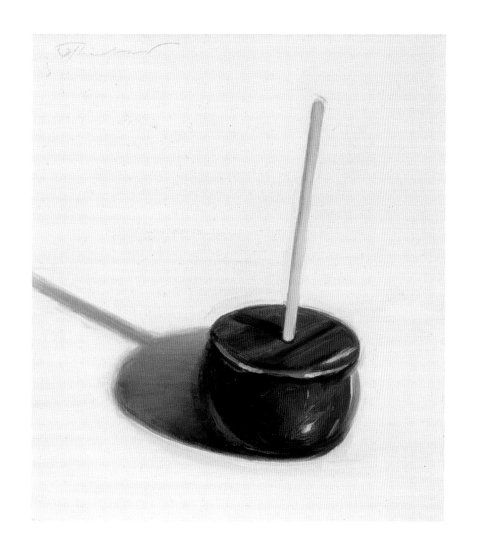

Dessert Circle, 1992–1994,
oil on panel, 21¼ x 18 in.
(54 x 46 cm)

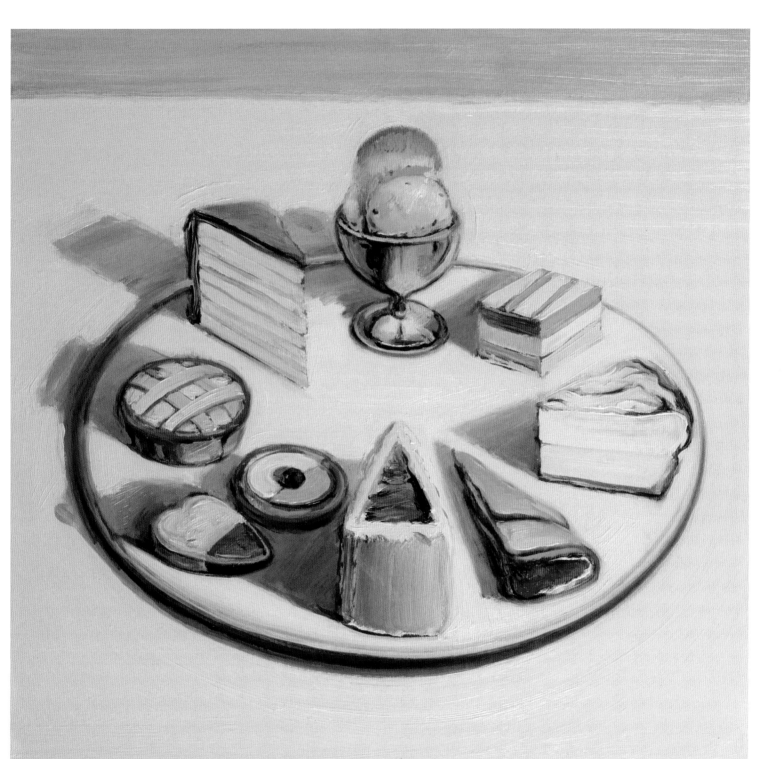

Two Heart Cakes, 1994,
oil on linen, 28 x 22 in.
(71 x 56 cm)

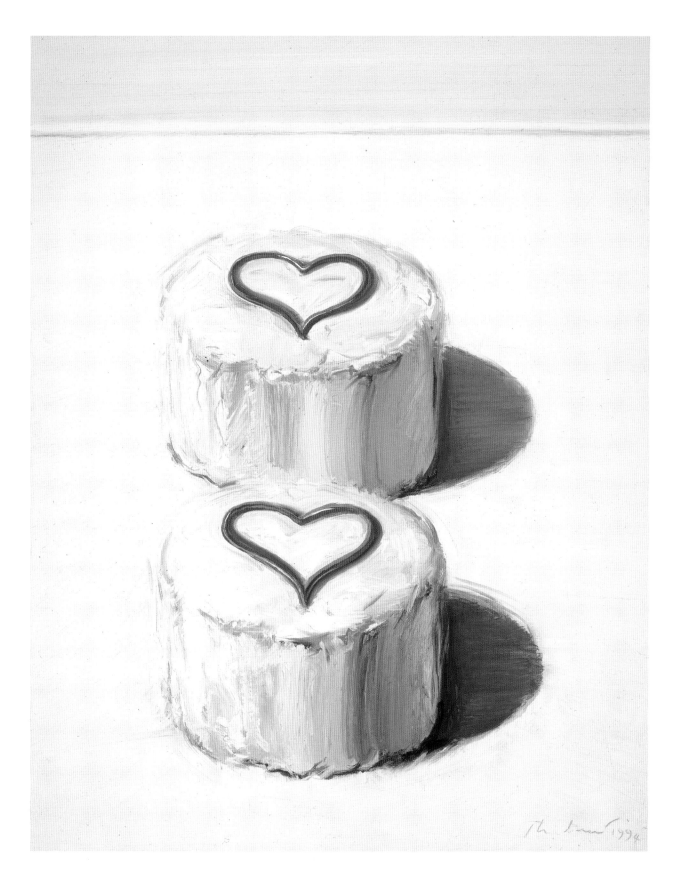

Party Tray, 1994,
oil on wood, 20 x 22 in.
(51 x 56 cm)

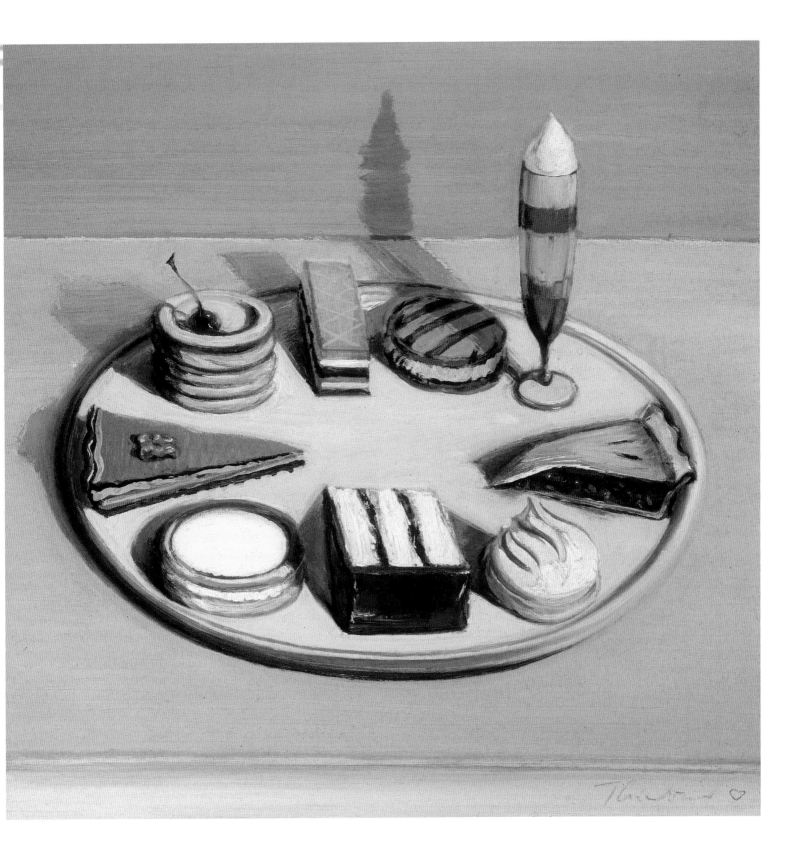

34

Dessert Table, 1996,
oil on canvas, 48 x 60 in.
(122 x 152.5 cm)

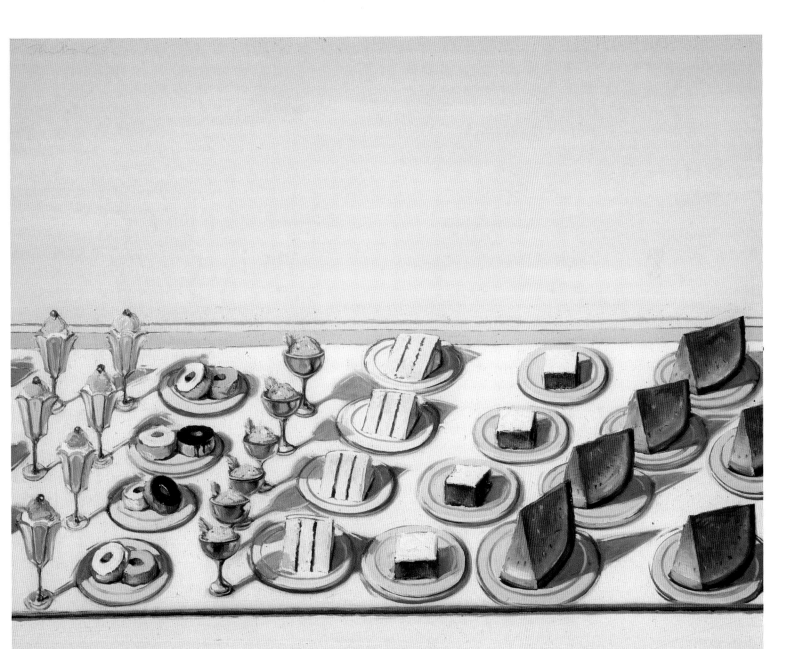

Bakery Case, 1996,
oil on canvas, 60 x 72 in.
(152.5 x 183 cm)

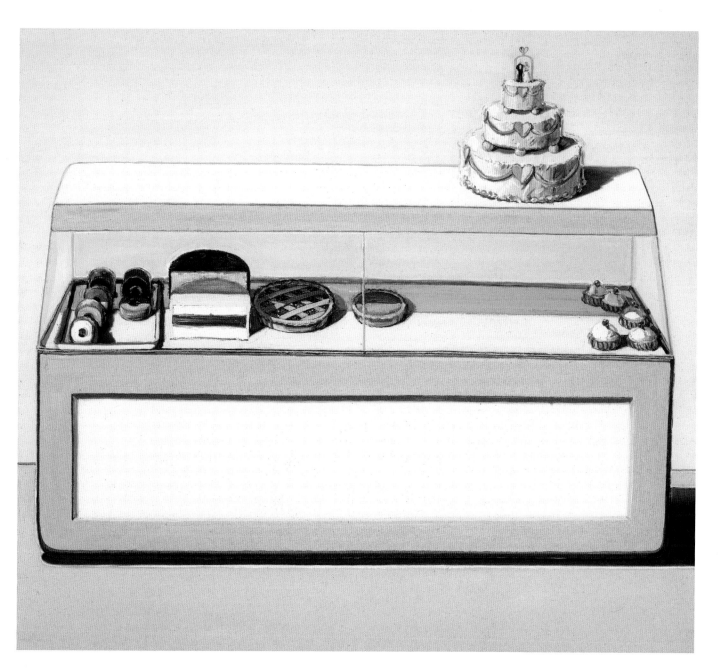

38

Ten Candies, 2000,
pastel on paper, 16 x 11 in.
(40.5 x 28 cm)

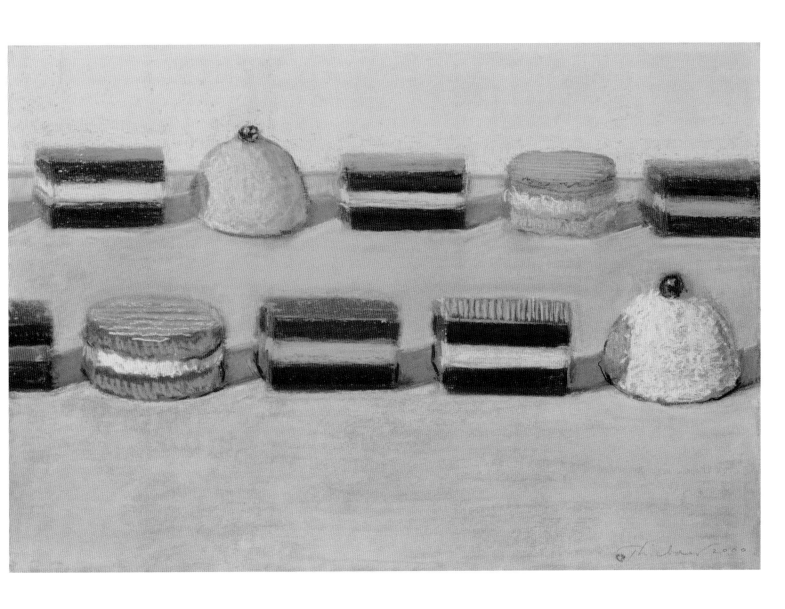

Dessert Rows, 2002,
oil on canvas, 11¾ x 11¼ in.
(30 x 28.5 cm)

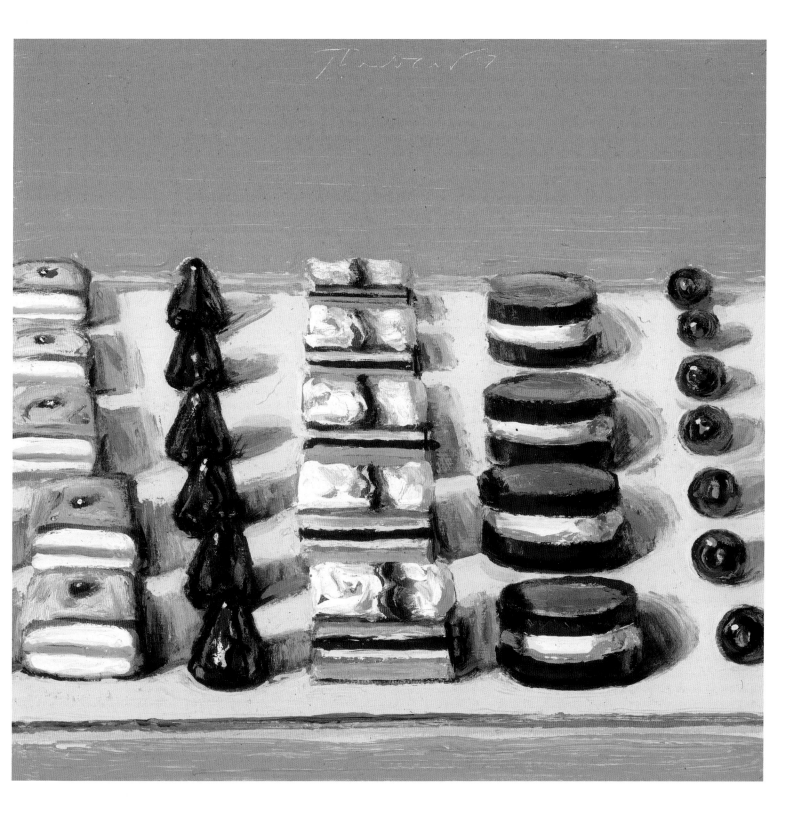

Dessert Cart, 2003,
oil on canvas, 48 x 60¼ in.
(122 x 153 cm)

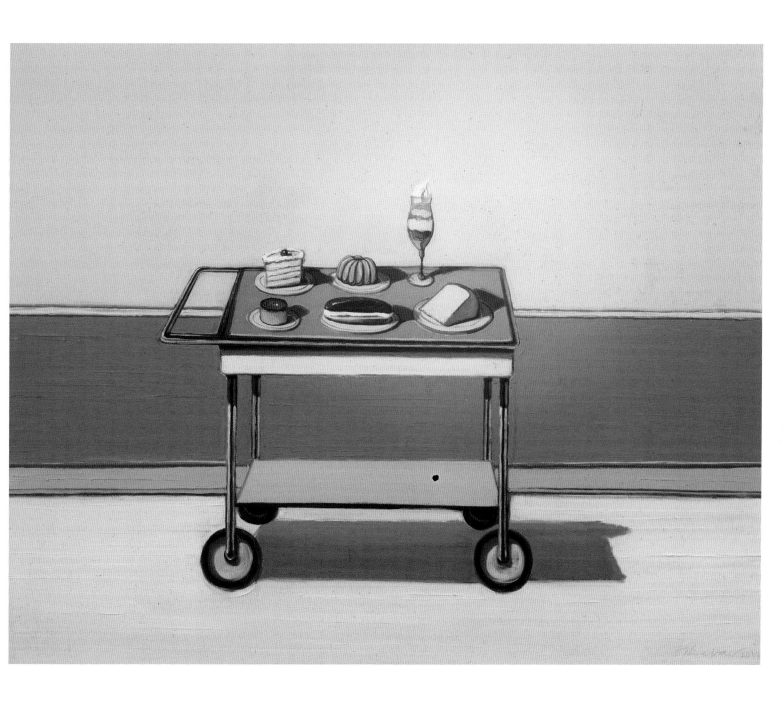

44

Crown Tart, 2005,
oil on board, 17 x 21¾ in.
(43 x 55 cm)

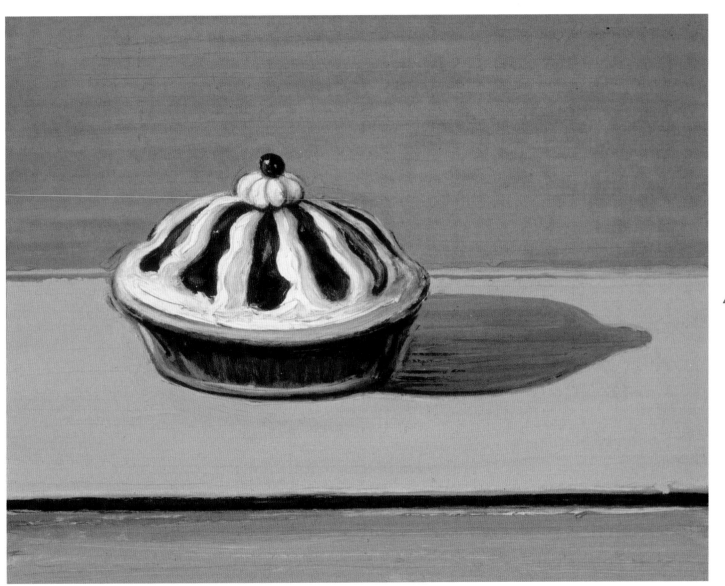

46

Cake Canopy, 2008,
oil on canvas, 16 x 12 in.
(40.5 x 30.5 cm)

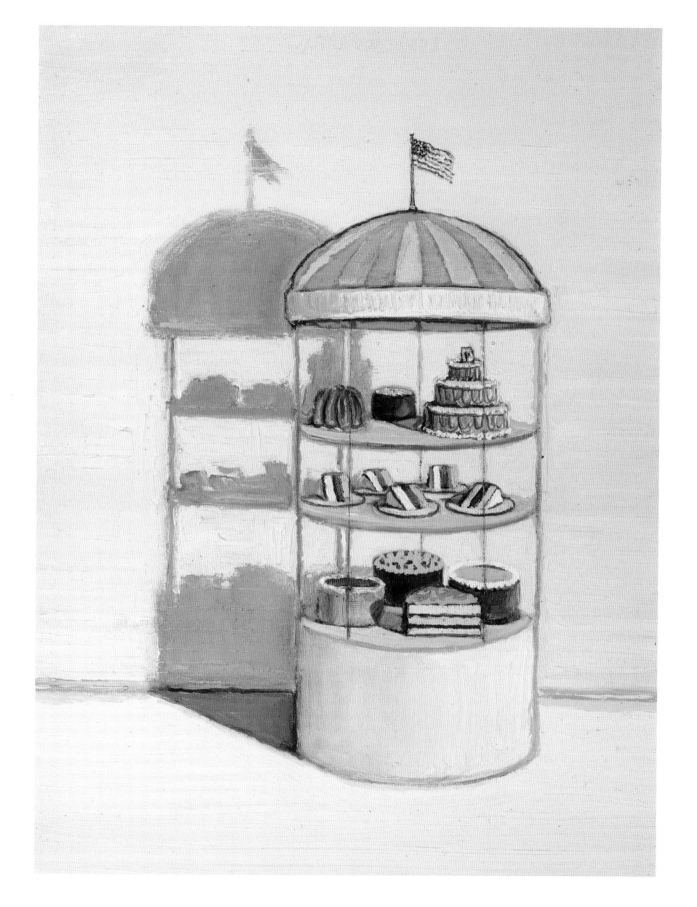

Cafeteria Table, 2012–2013, oil on canvas, 18 x 24 in. (45.5 x 61 cm)

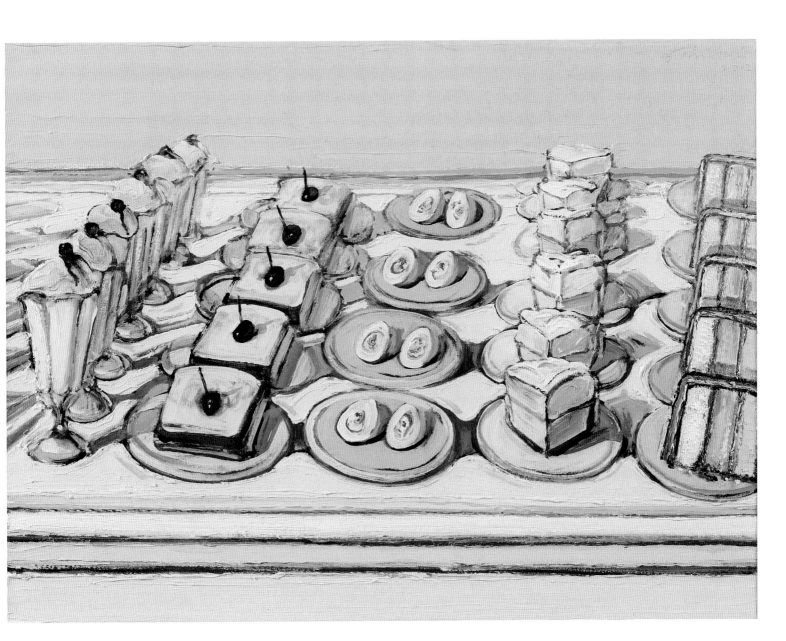

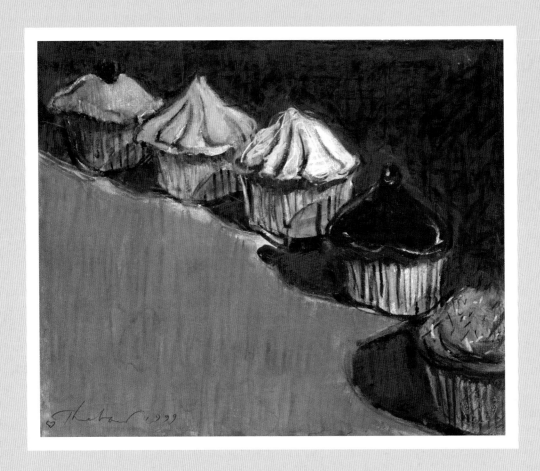

Five Cupcakes, 1999,
pastel on paper, 16 x 17½ in.
(40.5 x 44.5 cm)

Five Cupcakes
1999

Janet Bishop

Thomas Weisel Family Curator of
Painting and Sculpture,
San Francisco Museum of Modern Art

I once attended a dinner party in Davis, California, with Wayne Thiebaud. Before the first course was served, the then-96-year-old artist graciously offered to help the hosts with the appetizers by putting olives out for the guests. Rather than turning the container of olives that he was handed into a bowl with a single gesture, as most of us would, Thiebaud transferred them onto a platter, one by one, with little spaces between them, until they formed a perfect ring, just like in his paintings. With Thiebaud, every olive, deviled egg, lollipop, cupcake, or slice of pie is treated with respect. Every object he draws or paints, whether from observation, or more typically his imagination, is valued for its distinct physical character. Everything gets its own space.

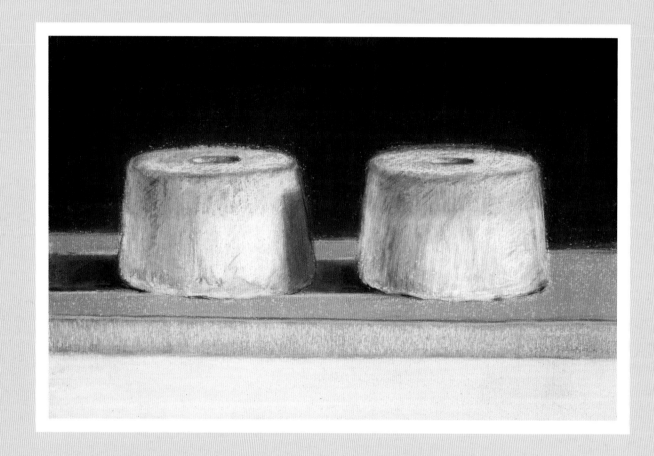

Angel Foods, 2000,
pastel on paper mounted on board,
17½ x 27 in. (44.5 x 68.5 cm)

Angel Foods
2000

Clay Vorhes
Artist

When I first discovered Wayne Thiebaud's paintings, it was evident he was a master of singular depth. Due to the draftsman's unique style and my own biased naïveté, the extent of those depths didn't crystalize until many years later. Suddenly . . . an epiphany of vision! The unending myriad of Thiebaud's paint manipulations unfurled themselves in unapologetic glory. A sight genesis of visual vocabulary emerged.

In a vast ocean, we painters are merely skimming the surface. Wayne Thiebaud swims in very deep waters. Regardless of subject matter, this master chef is alone in vision and execution. His are the brushstrokes of rarified air. Thiebaud is uniquely Thiebaud.

Although a lone wolf on the precipice of creation, the telltale signs of his predecessors remain. Thiebaud is a thief . . . a fox in the hen house. I mean this with the utmost respect. Indeed, he readily admits the larceny. Thiefdom exists, yet this painter morphs history into modern singular beauty. Thiebaud's visual repertoire is Jurassic in the universe of paint. What Thiebaud sees, he owns. All of vision is absorbed . . . this is a painter who accumulates, synthesizes, and transforms.

Within the sacred walls of historical brethren, Thiebaud transcends the painting medium. Simple beginnings finish at the nth degree. Modestly, the painter is an aptitude composite of universal ingredients. But Thiebaud's talent consumes predecessors. Like Seabiscuit, he separates himself with the sparkle, flair, and euphoria of a photo finish.

Oh to cook so masterfully! Thiebaud's endgame is an unbridled visionary treat: Cream rises. His creation is akin to an exquisite Michelin-starred delicacy. We all have the recipe, but we can't cook with the panache worthy of a James Beard Award. Thiebaud does . . . and so deceptively, he makes it look ever so easy.

A smattering of Thiebaud ingredients are as follows:

Mix the sweet lines of Matisse with the sautéed compositions of Morandi and Degas; add a sprinkle of Fantin-Latour's flowery precision with a pinch of Picasso; dash a splash of Bonnard's palette; and whisk with equal parts Rodin gravitas and Ingres empathy.

Voilà . . . the tasty Thiebaud!

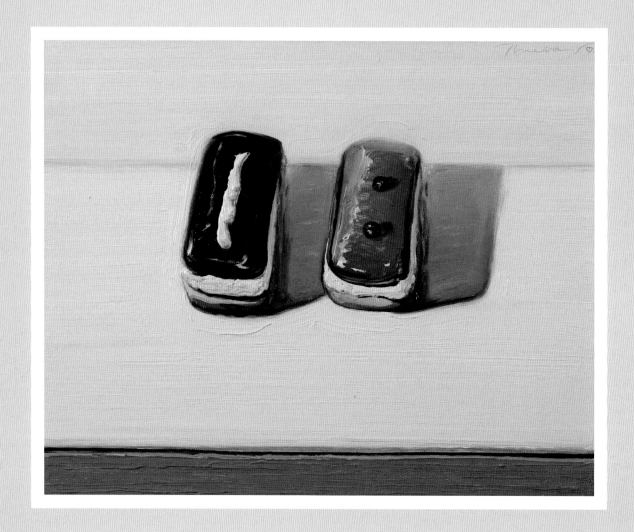

Chocolate & Maple, 2001,
oil on canvas, 16 x 19¾ in.
(40.5 x 50 cm)

Chocolate & Maple
2001

Fred Dalkey
Artist

In the late 1950s, I was just starting to paint. At the Crocker Art Museum, I encountered a painting of an electric chair by Wayne Thiebaud. I was appalled. Such a horrifying image! How could anyone do that to the dignified activity of painting?

I was an idiot, of course—naïve and inexperienced.

My next encounter with his work was a show of still life paintings of pumpkin pies, hamburgers, and other banal foodstuffs. Shocked again, I wondered why he was doing that.

Still an idiot, I was not yet willing to be thrilled by his daring.

Then he did it again. His series of figures and portraits weren't the warm, soulful works of a Rembrandt, my measure of that tradition. Instead, they were images of isolated modern people that I found rather cold. Once again, he continued to upend my sense of propriety.

But for some reason I was unable to ignore his art. And then, my God! I realized: Wayne Thiebaud was reinventing painting.

Here is an artist who is able to address traditional themes with traditional materials that many consider moribund and give them new life. His work still shocks me, but instead of regarding that as a negative, I give thanks.

55

56

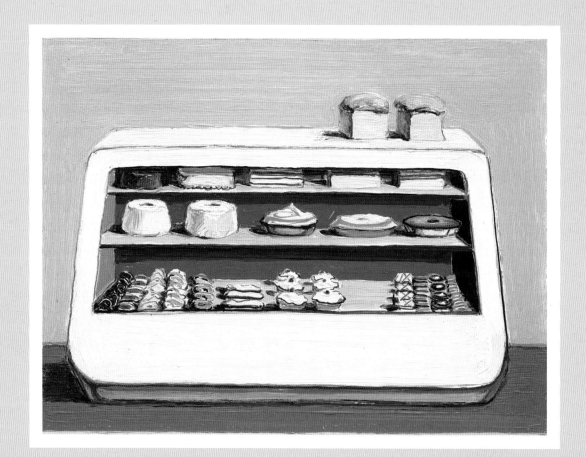

Bakery Counter, 1993,
oil on paper, 9 x 12 in.
(23 x 30.5 cm)

Bakery Counter

1993

Scott A. Shields, PhD

Associate Director and Chief Curator, Crocker Art Museum

As much as for their subject matter and color, Wayne Thiebaud's paintings are truly set apart by their brushwork. His strokes are applied with sensitivity—and precision—and they artfully detail whatever he decides to paint. These are not short, choppy swatches, but long, carefully laid swathes, which the viewer can follow up, down, and sideways. They overtly fill the forms and trace the outlines of desserts, buildings, landscapes, and people, contouring to the object or person to best connote texture and mass. Sometimes this brushwork builds up into expressive areas of impasto. Other times it subtly animates large, flat expanses, with every hair raked into the pigment like the carefully manicured sands of a Zen garden.

At their core, therefore, these are paintings about painting, and while Thiebaud's subject matter and bright colors may be described as Pop, his brushwork most certainly cannot. This affinity for brushwork and an abiding respect for the artist's craft sets Thiebaud's work apart, along with that of other artists of his circle, place, and time. His is a Northern California sensibility, one distinct from that of New York artists like Andy Warhol and Roy Lichtenstein, who pursued a mechanical—and more cynical—means of paint application. Warhol silkscreened his Campbell's Soup cans, Coca-Cola bottles, and celebrities, effacing his own role in the process. Roy Lichtenstein's comic-book, Ben-Day dots accomplished a similar result, sacrificing painting in favor of a "mass produced" style that linked the artist and the machine. Thiebaud's paintings, by contrast, are deeply personal and unabashedly handmade, which makes them inherently more optimistic, because they are so obviously labored over and loved. While Warhol seems not to have liked soup, Thiebaud certainly enjoys his pie. This should not imply that Thiebaud's paintings do not comment on consumerism and the isolation that one can feel even in an oversaturated world. They do. And yet, in their care and undeniable reverence for painting, they are also celebratory, validating art, the role of the artist, and the delicious idiosyncrasies of contemporary life.

57

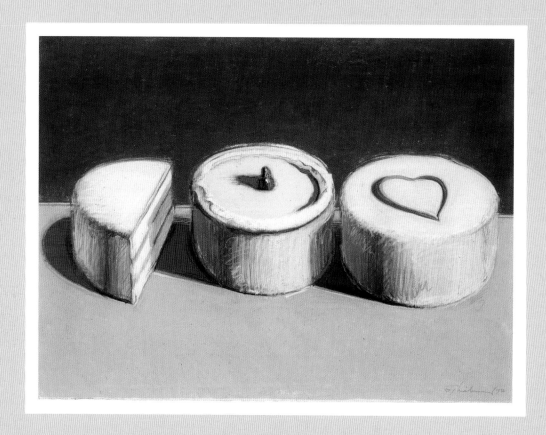

Two and One-Half Cakes, 1972,
pastel on paper, 22⅛ x 30 in.
(56 x 76 cm)

Two and One-Half Cakes
1972

Michael Zakian

Director, Frederick R. Weisman Museum
of Art, Pepperdine University

Thiebaud's desserts are so memorable because these realist images are based on fundamental abstract shapes. In this work, the three-dimensional mass of the layer cake is developed from essential cylinders, rendered in perspective. He once explained:

"When I painted food products it is interesting to note that they were painted from memory. I did not have the objects in front of me. I made it a point to paint the pies, the gumball machines, the cakes, etc., as I remembered them. And this is perhaps what makes them seem like icons, in a sense. They're greatly conventionalized."

Because he used basic geometric forms as the heart of his food, they transcend traditional realism. They possess a graphic force and an abstract quality that make them riveting and unforgettable. Thiebaud learned these techniques while working as a designer and commercial artist in the late 1940s. They became the principles behind his mature, signature style and helped his work bridge the gap between traditional realism and the dominant abstract styles of the 1960s.

59

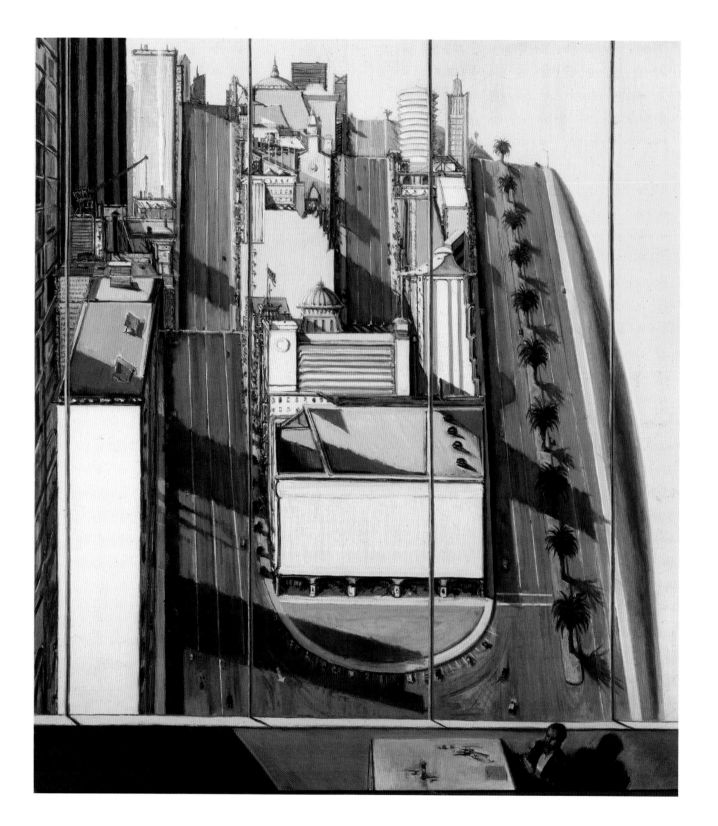

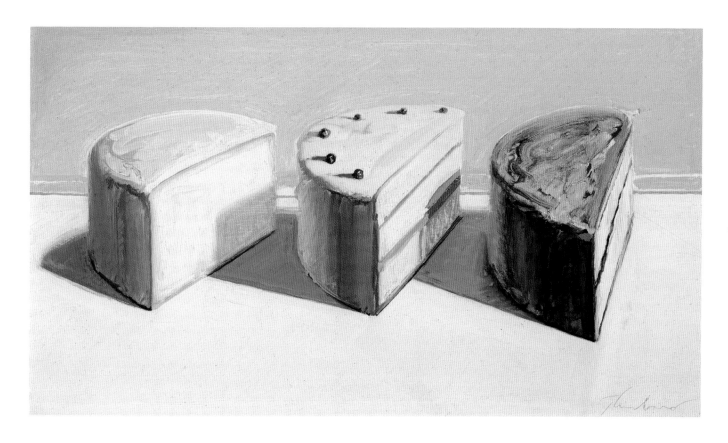

Window Views, 1989–1993, oil on canvas,
72 x 64¼ in. (183 x 163 cm)

Three Half Cakes, 1986, oil on canvas,
18 x 30 in. (45.5 x 76 cm)

Elevated Freeway, 1998,
acrylic on canvas, 72 x 72 in. (183 x 183 cm)

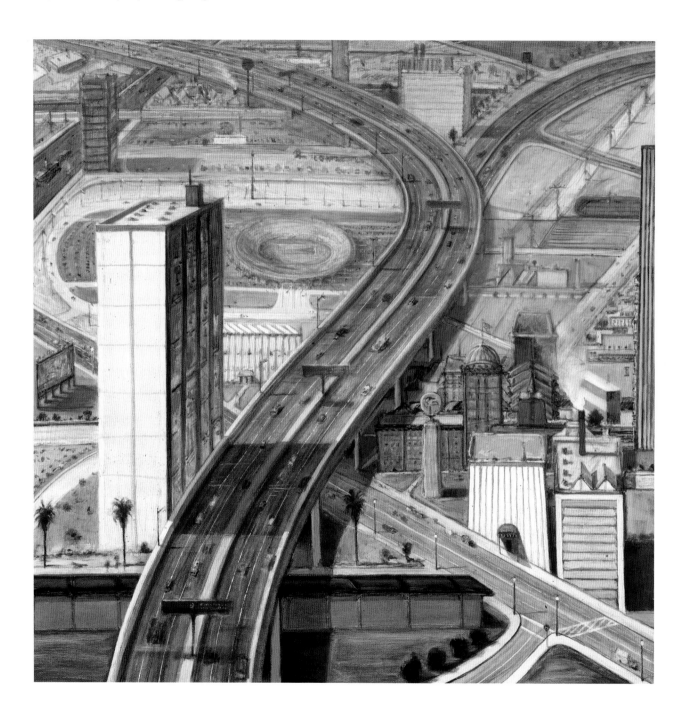

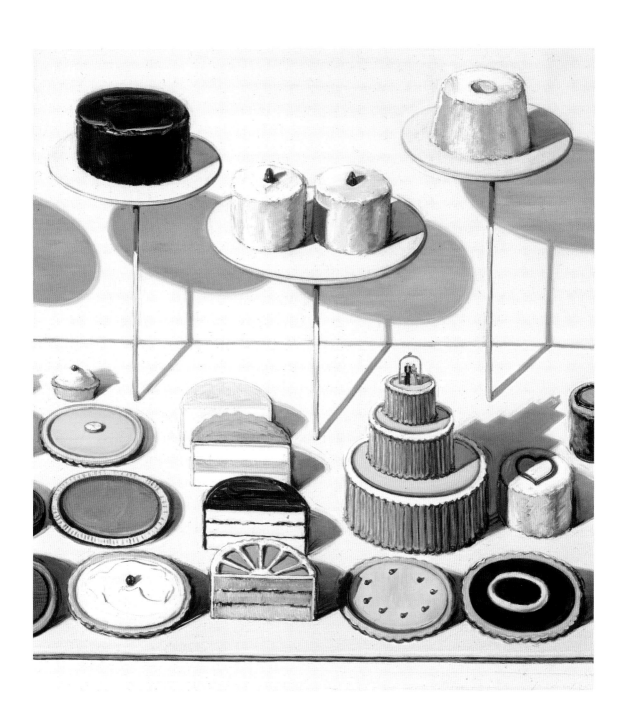

Cakes and Pies, 1995,
oil on linen, 60 x 48 in. (152.5 x 122 cm)

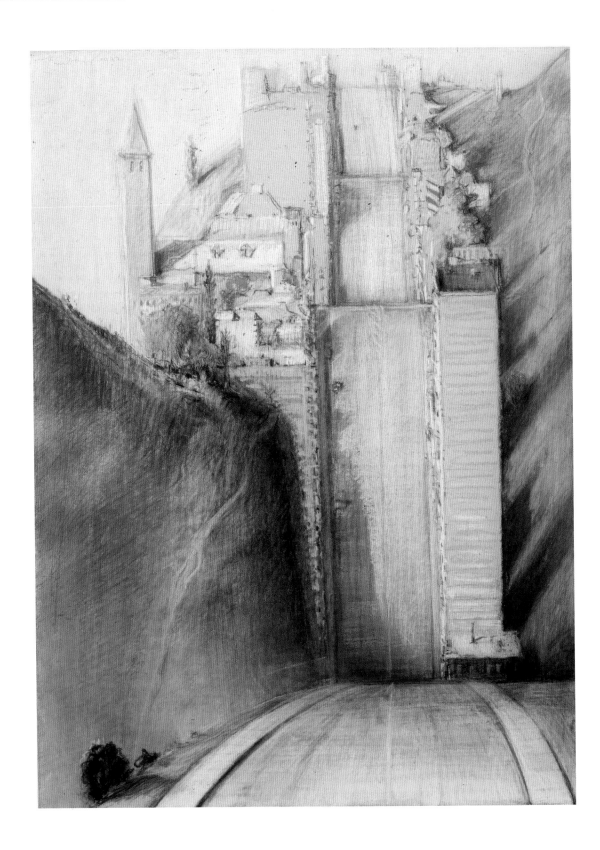

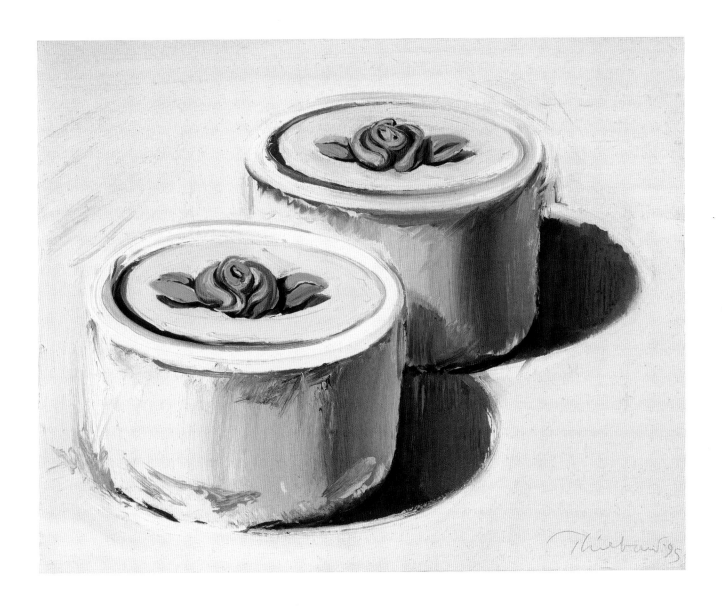

Park Place (study), 1992,
pastel on paper, 30 x 22 in. (76 x 56 cm)

Rosebud Cakes, 1991–1995,
oil on canvas, 15⅞ x 20 in. (40.5 x 51 cm)

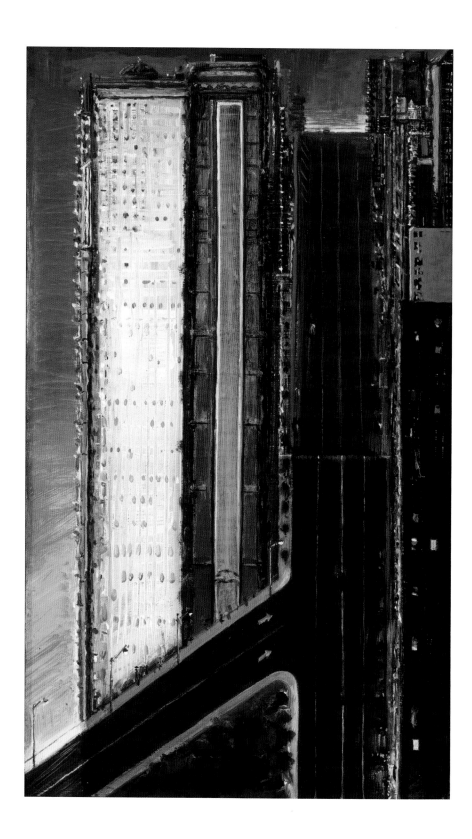

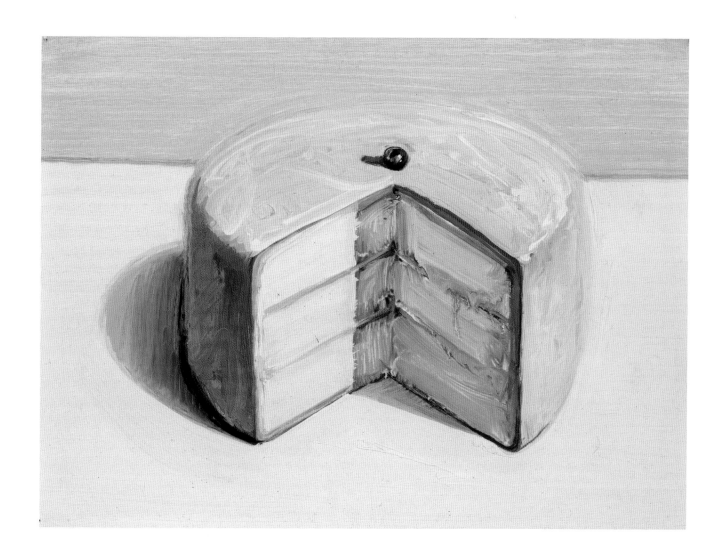

Night Streets, 1990,
oil on panel, 20½ x 20¼ in. (52 x 51.5 cm)

Lemon Cake, c. 1983,
oil on paper mounted on board,
11⅛ x 15⅛ in. (28.5 x 38.5 cm)

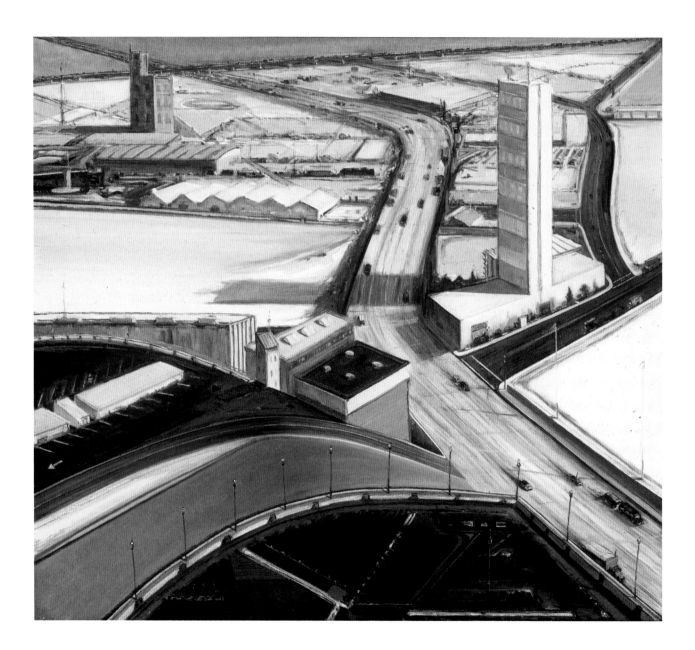

Towards 280, 1999–2000,
oil on canvas, 54 x 60 in. (137 x 152.5 cm)

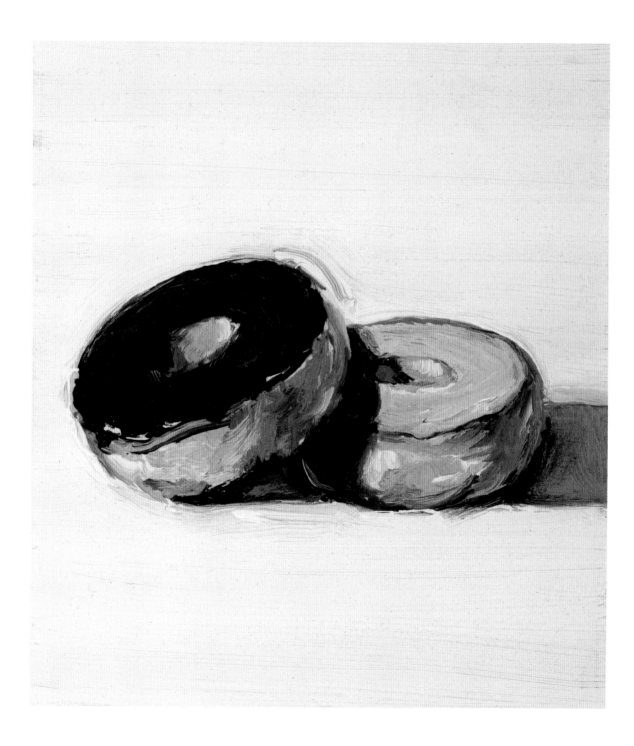

Two Donuts, n.d.,
oil on paper, 5½ x 4⅞ in. (14 x 12.5 cm)

Apartment Hill, 1980,
oil on linen, 65 x 48 in. (165 x 122 cm)

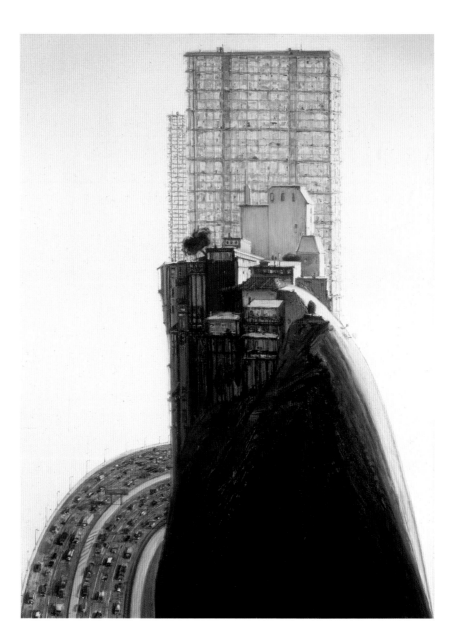

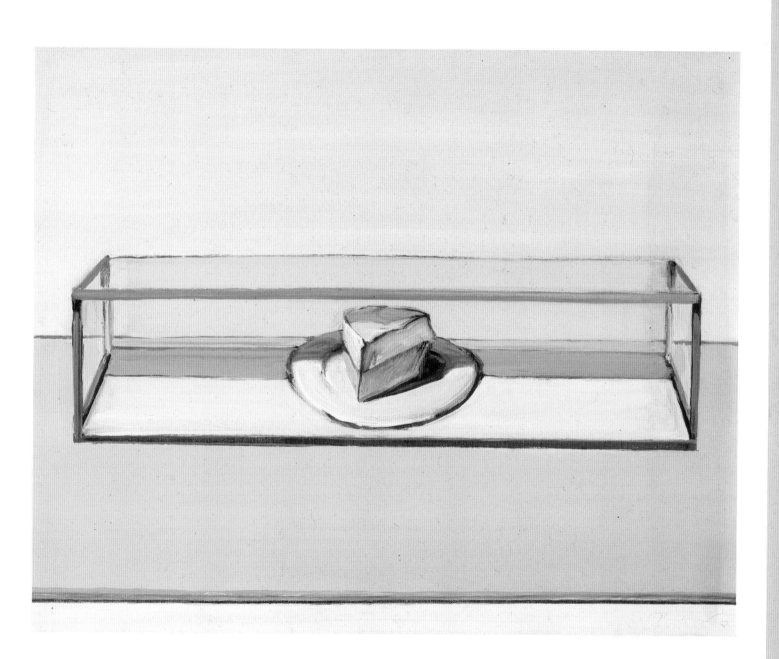

Cased Pie, c. 1972,
oil on canvas, 22 x 28 in. (56 x 71 cm)

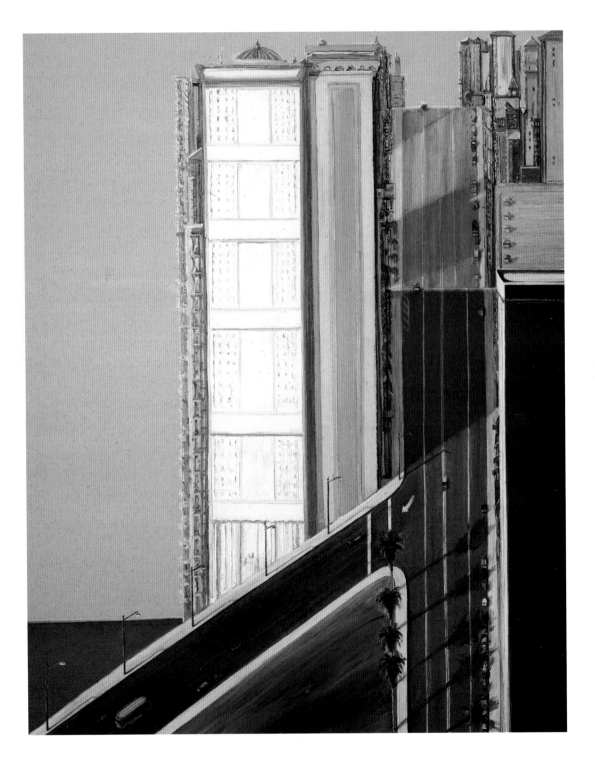

Day Streets, 1996,
oil on canvas, 60 x 48 in.
(152.5 x 122 cm)

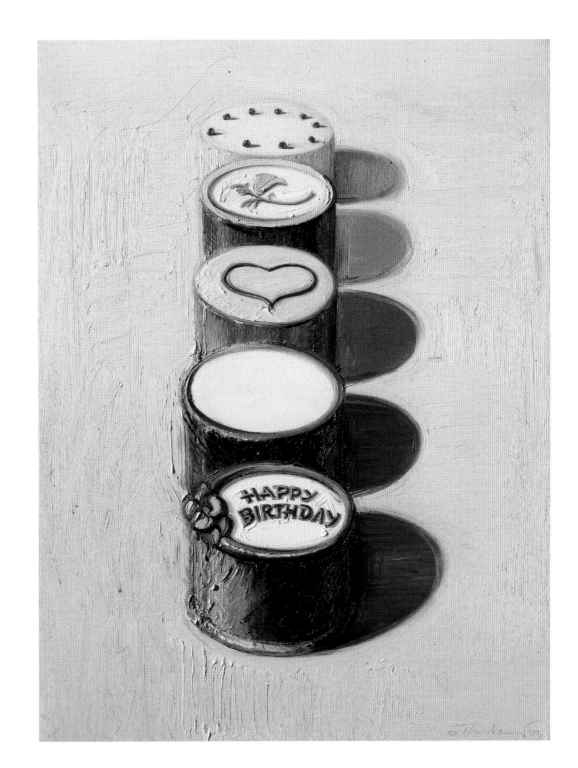

California Cakes, 1979,
oil on canvas, 48 x 36 in.
(122 x 91.5 cm)

Urban Freeways, 1979,
oil on canvas, 44⅜ x 36⅛ in. (112.5 x 92 cm)

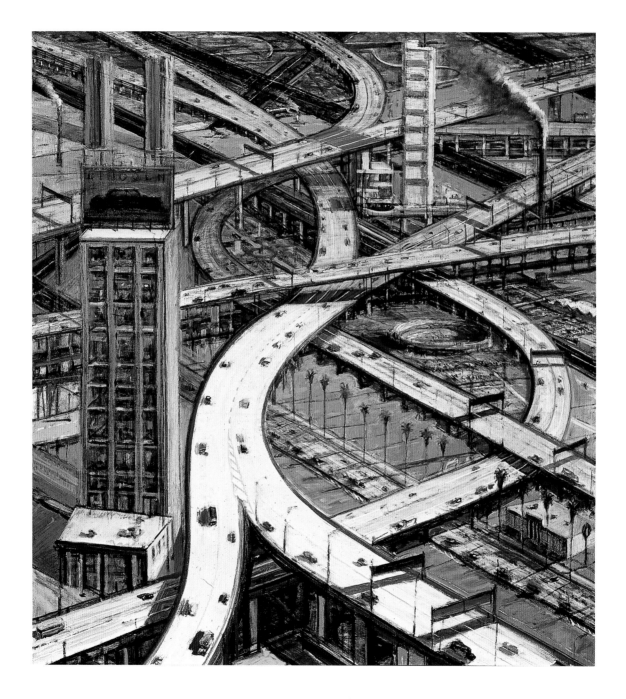

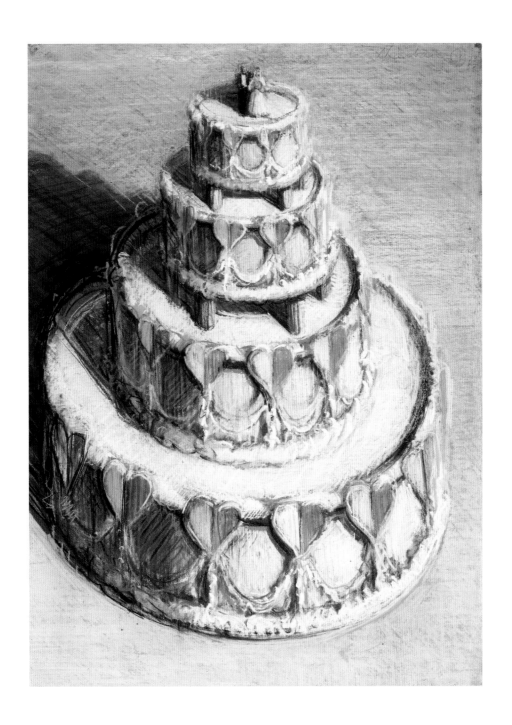

Wedding Cake, 1973–1982,
pastel on paper, 32 x 28 in. (81.5 x 71 cm)

Circle Street, 1985,
oil on canvas, 48 x 48 in. (122 x 122 cm)

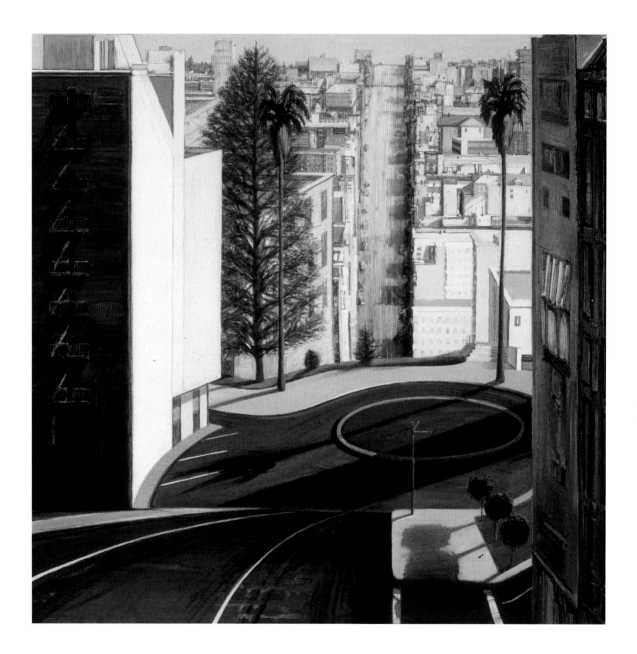

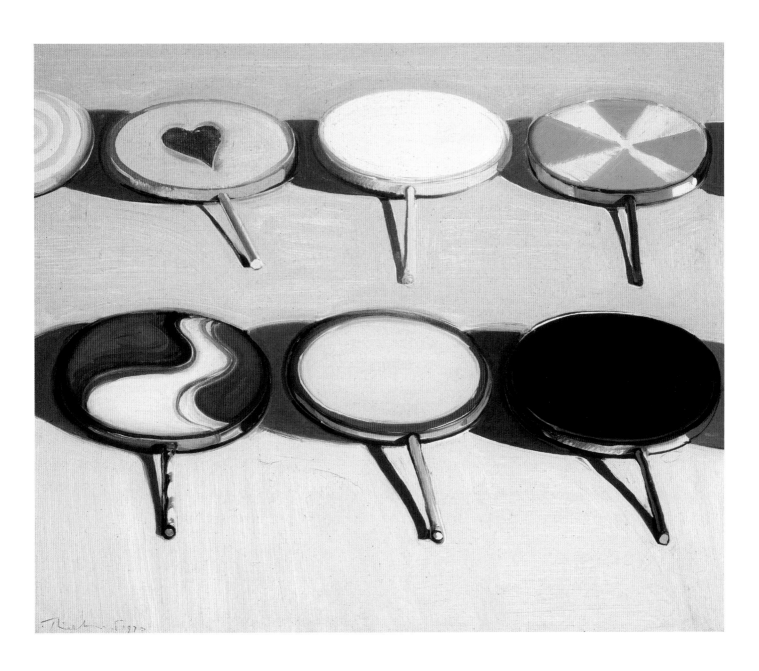

Seven Suckers, 1970,
oil on canvas, 19 x 23 in. (48.5 x 58.5 cm)

Diagonal Ridge, 1987,
watercolor on paper, 11 x 15 in. (28 x 38 cm)

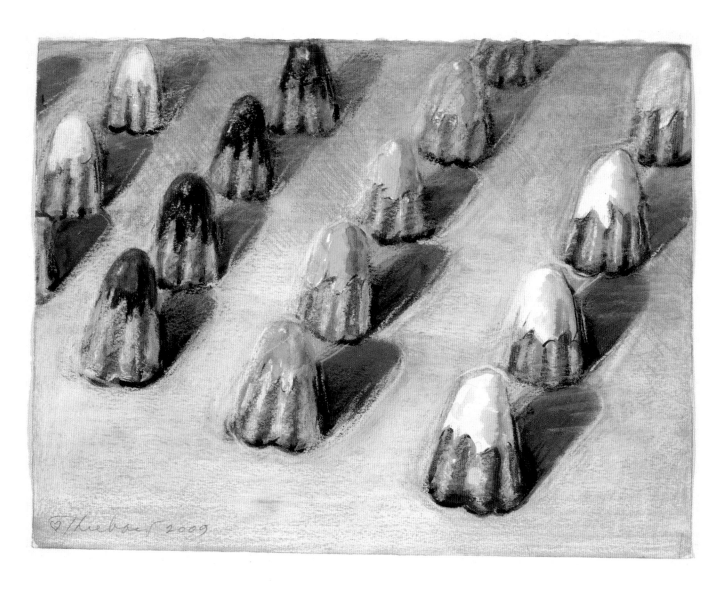

Iced Macaroons, 2009,
pastel on paper, 11¼ x 14⅞ in. (28.5 x 38 cm)

West Side Ridge, 2001,
oil on canvas, 36 x 36 in. (91.5 x 91.5 cm)

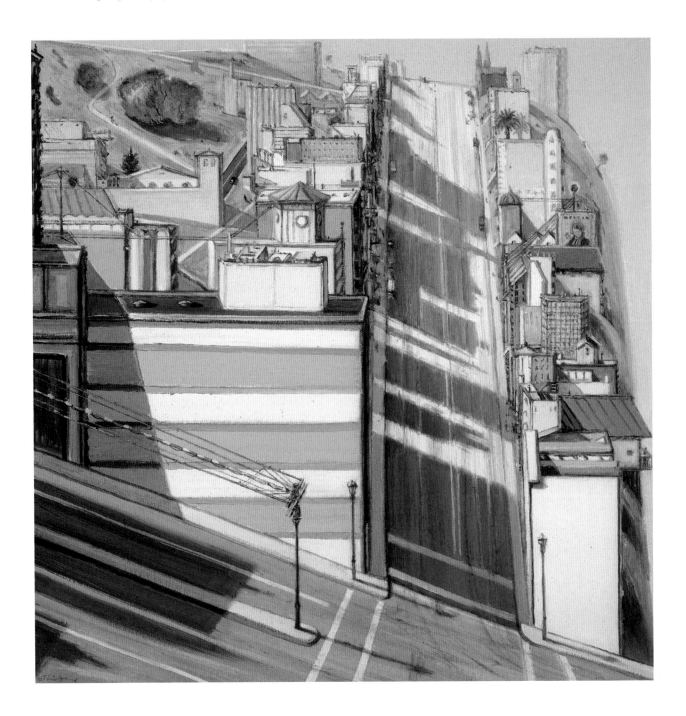

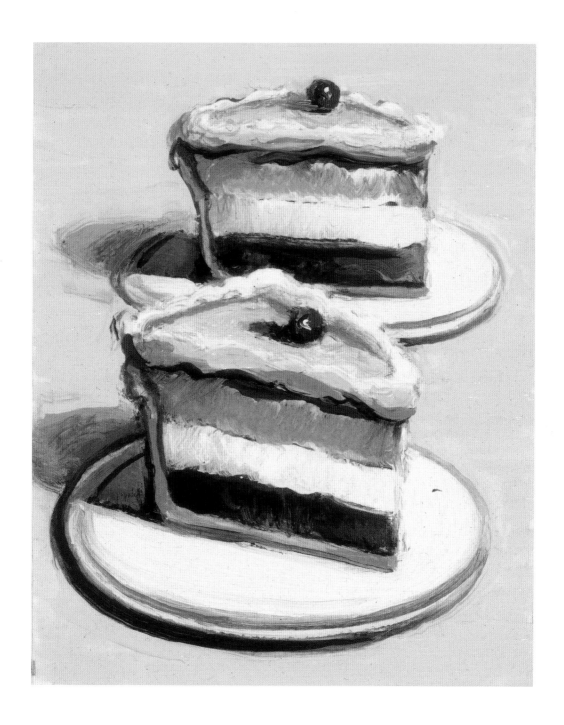

Two Neapolitan Pie Slices, 2004,
oil on paper, 5 x 4 in. (12.5 x 10 cm)

Travelers, 1997,
oil on canvas, 22 x 48 in. (56 x 122 cm)

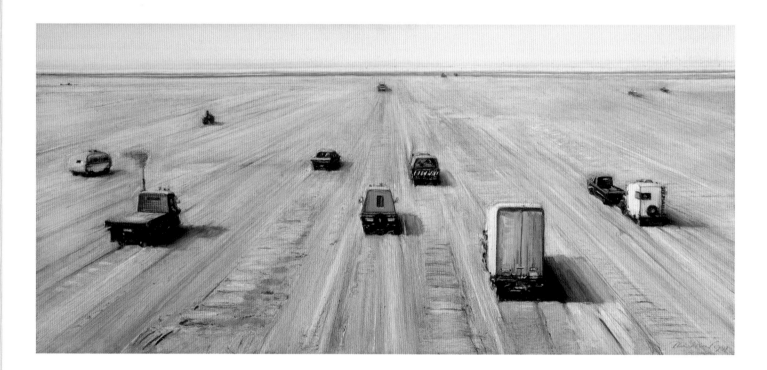

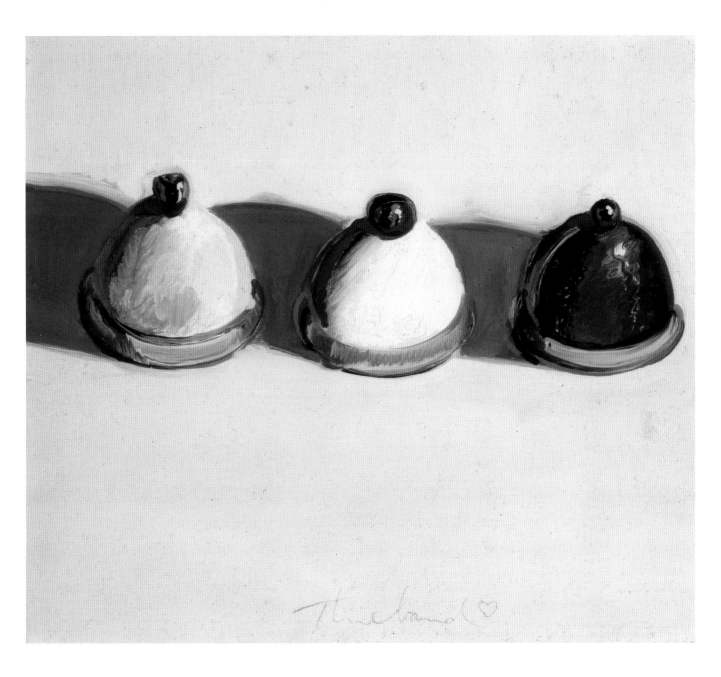

Three Treats, c. 1972,
oil on wood, 10½ x 12 in. (26.5 x 30.5 cm)

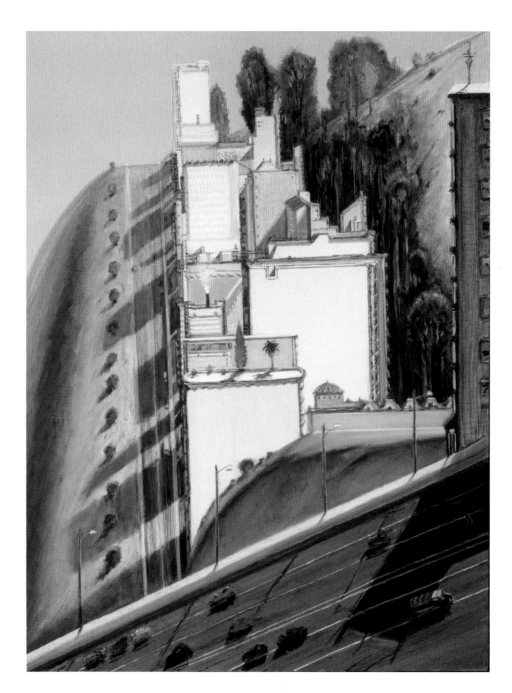

Potrero Grove, 1999,
oil on canvas,
40 x 30 in.
(101.5 x 76 cm)

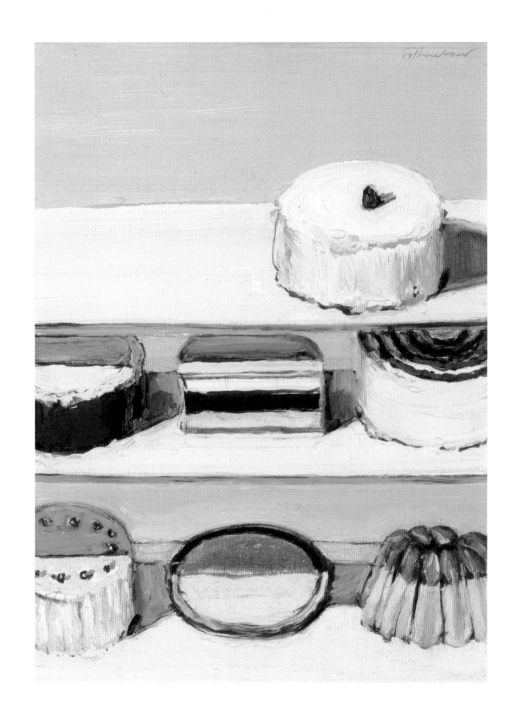

Shelf Cakes, 2008,
mixed media on paper
mounted on board,
16 x 12 in.
(40.5 x 30.5 cm)

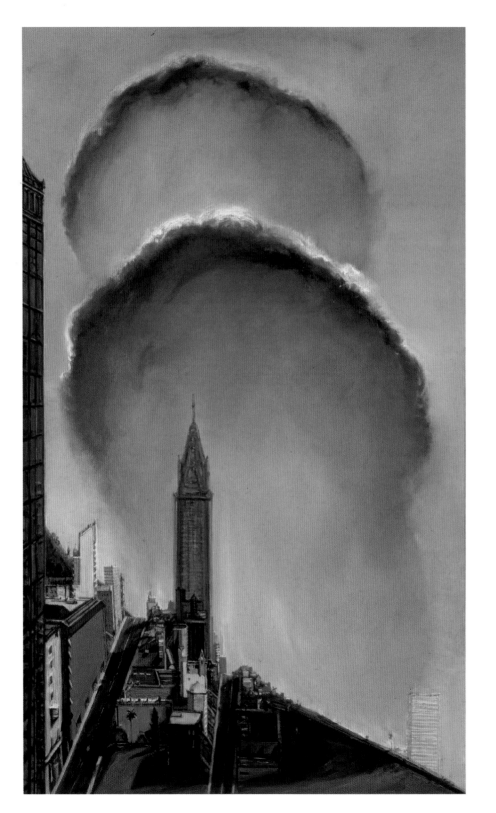

Cloud City, 1993–1994,
oil on canvas,
60 x 36 in.
(152.5 x 91.5 cm)

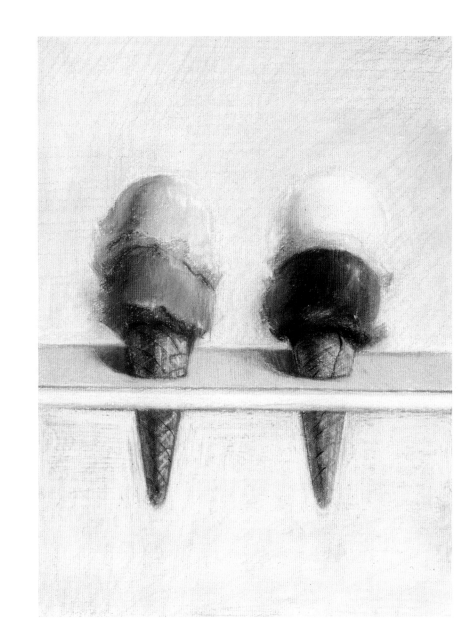

Four Flavors, c. 1990,
pastel on paper,
12 x 9 in. (30.5 x 23 cm)

87

Uphill Streets, 1992–1994,
oil on canvas, 60¼ x 48¼ in. (153 x 122.5 cm)

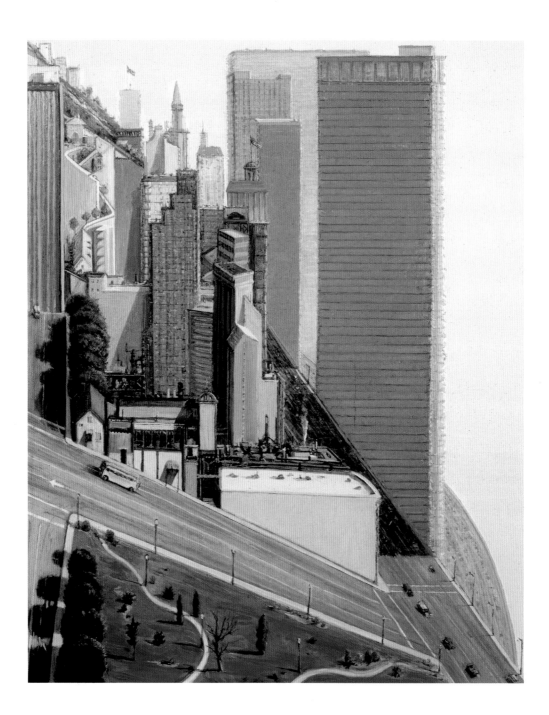

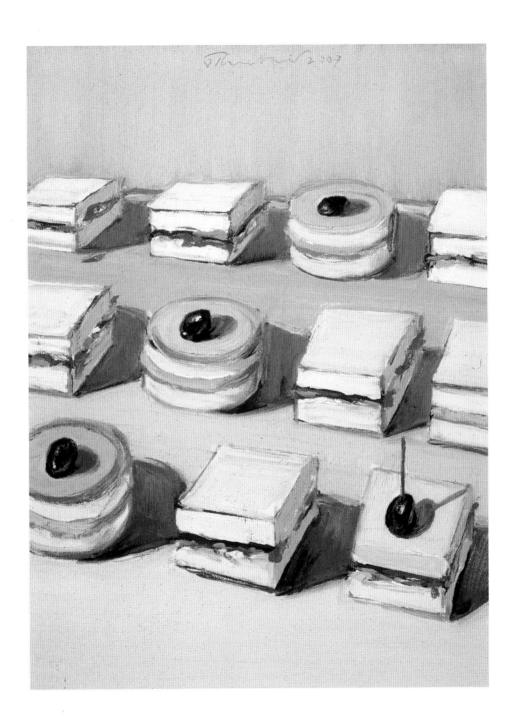

Tea Sandwiches, 2007,
oil on canvas, 16 x 12 in. (40.5 x 30.5 cm)

Park Place, 1993,
oil on canvas, 60¼ x 54 in. (153 x 137 cm)

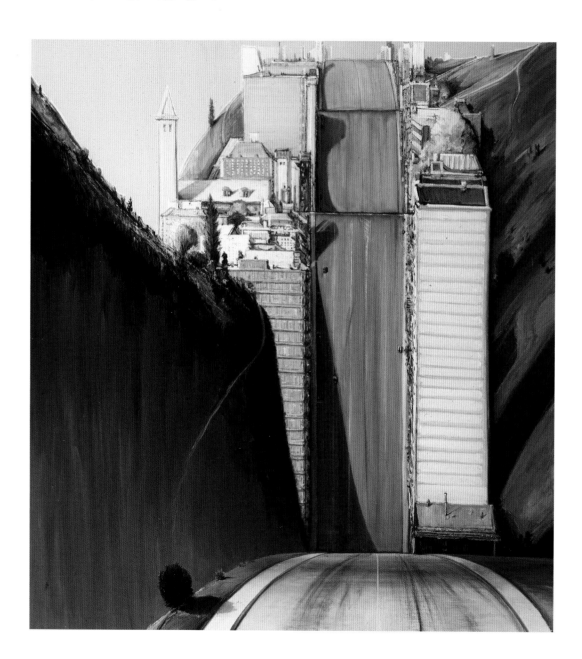

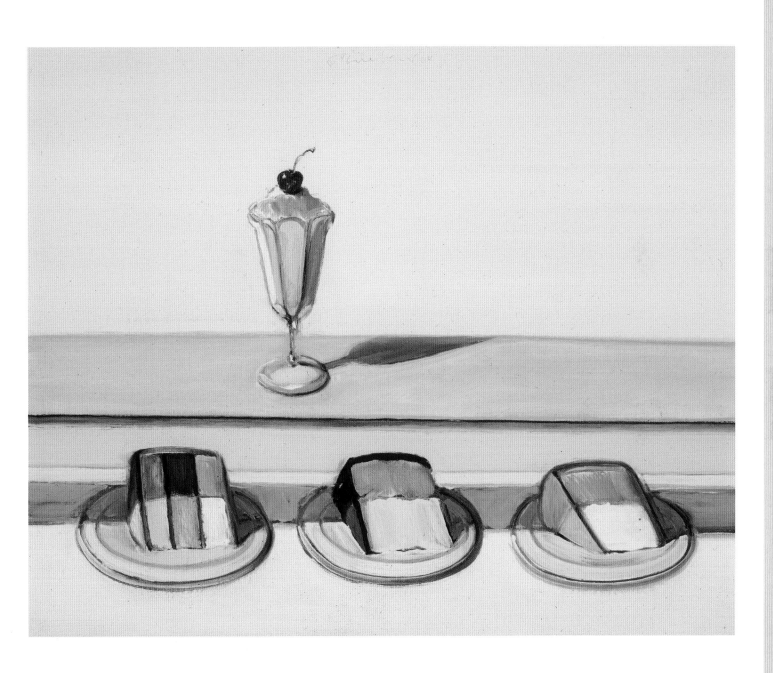

Dessert Choices, 2004,
oil on canvas, 24 x 30 in. (61 x 76 cm)

Freeway Interchange, 1982,
oil on canvas, 30 x 24 in. (76 x 61 cm)

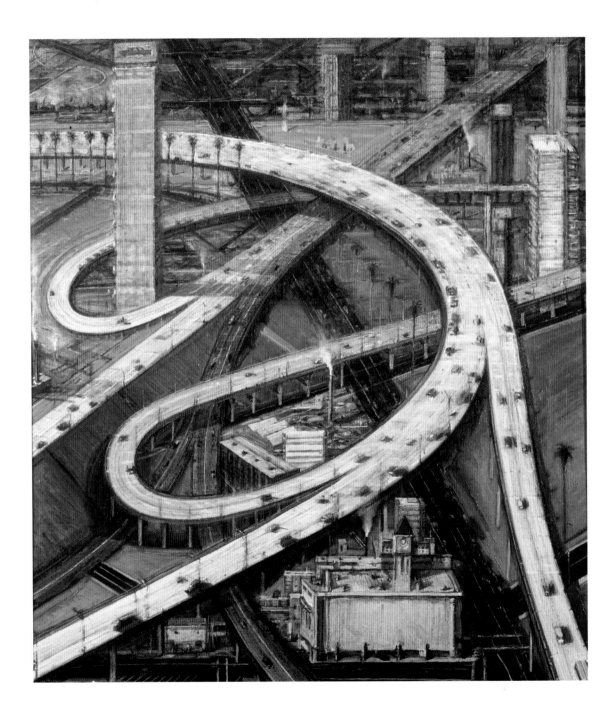

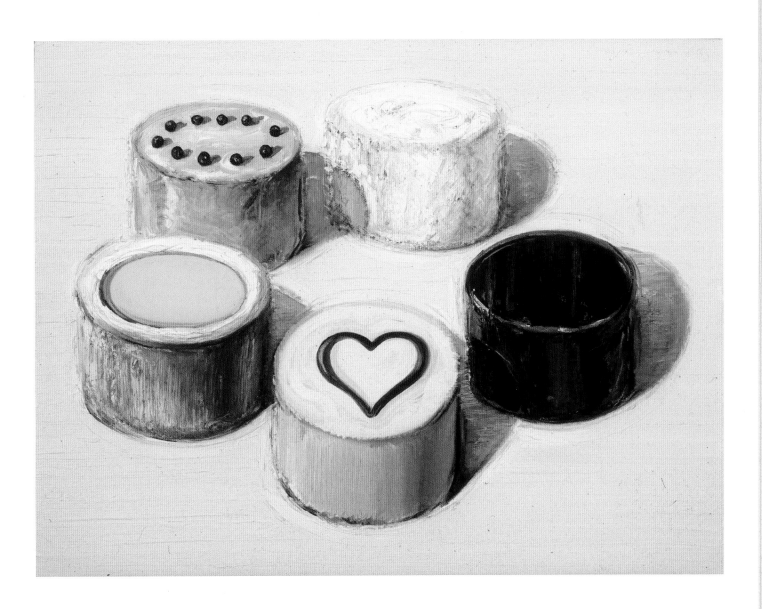

Cake Assembly, 2005,
oil on canvas, 24¾ x 33¼ in. (63 x 84.5 cm)

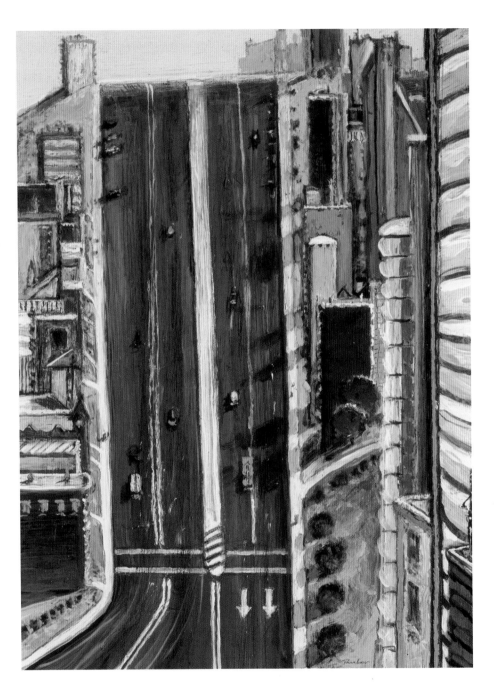

Two Streets Down, n.d.,
oil on board, 9⅞ x 7⅜ in.
(25 x 18.5 cm)

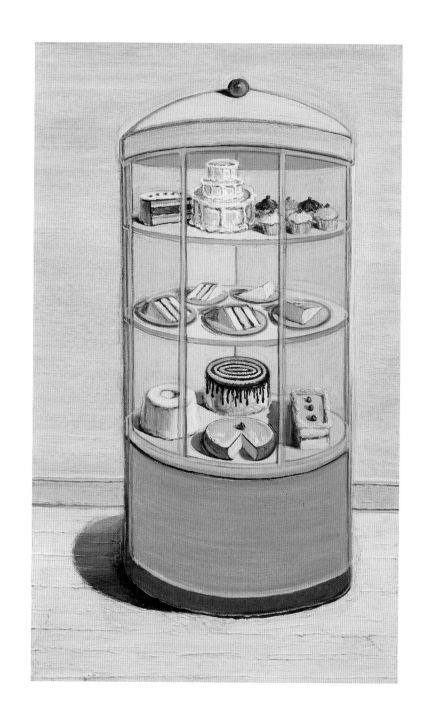

Circle Cake Case, 2008,
oil on canvas, 60 x 36 in.
(152.5 x 91.5 cm)

24th Street Intersection, 1977,
oil on canvas, 35⅝ x 48 in. (90.5 x 122 cm)

96

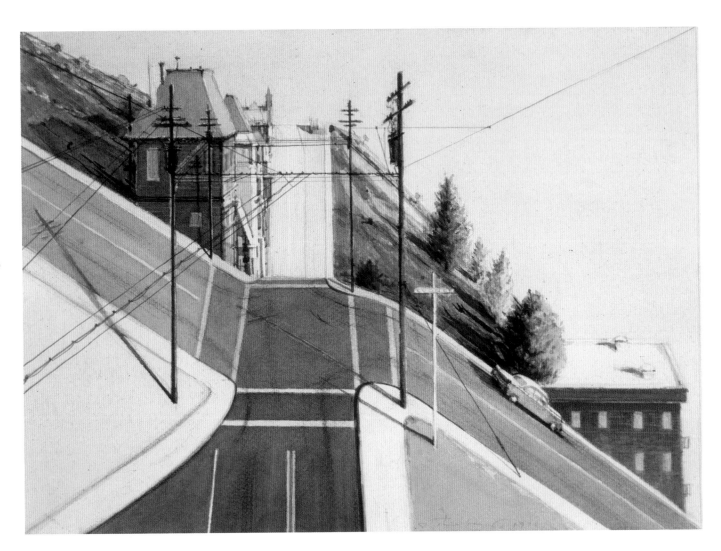

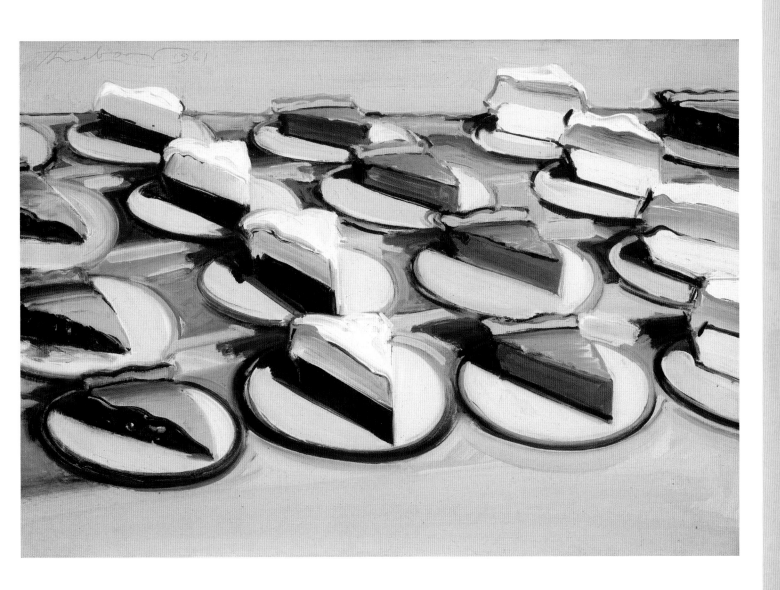

Pie Rows, 1961,
oil on canvas, 18 x 26⅛ in. (45.5 x 66.5 cm)

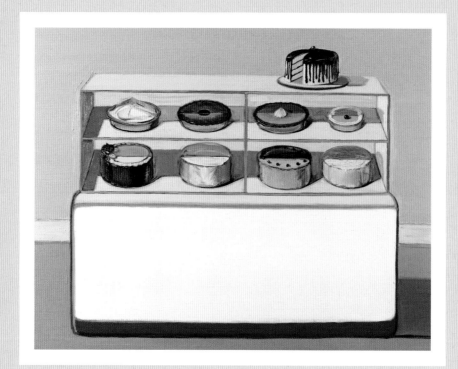

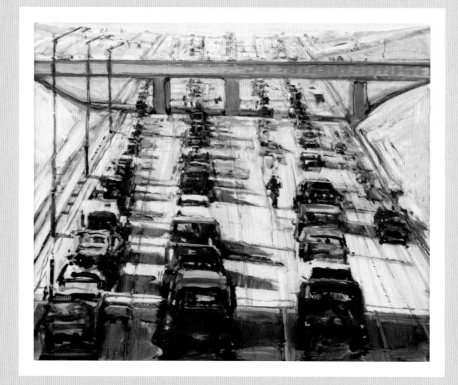

Cold Case
2010–2013

Heavy Traffic
1988

Victoria Dalkey

Art critic, *The Sacramento Bee*

Wayne has a genius for finding things so familiar, we often overlook them and certainly don't think of them as subjects for art. His first paintings of pies and cakes befuddled viewers and critics alike. Even Allan Stone, who introduced them to a national audience, at first thought Wayne was "nutso."

But his images of sugary treats, often arrayed in rows under bright, artificial light in spare, air-conditioned environments on surfaces suggestive of cafeteria counters or bakery cases, were a hit with New York collectors, curators, and critics in the 1960s, who saw them as examples of Pop Art. Today these formally inventive, lushly painted, architectural "pleasure domes" continue to be a mainstay of his practice.

Similarly, Wayne's images of freeways begun in the 1980s focus on phenomena we experience every day but wouldn't at first think appropriate subjects for the kind of intense looking involved in making art. His gritty paintings of cars backed up and inching along at rush hour or speeding on dizzying cloverleaf interchanges veer from a kind of slapstick comedy to menacing parables of monotonous modern life, inviting us to reconsider an environment in which we spend much of our lives.

Arising from both memory and observation, these iconic images, falling somewhere on a spectrum between representation, realism, naturalism, and what Wayne once described as "actualism," explore not only the essential nature of things but also the process of seeing itself.

99

Cold Case, 2010–2013,
oil on canvas, 60 x 48 in. (152.5 x 122 cm)

Heavy Traffic, 1988,
oil on paper mounted on board, 14 x 16⅝ in. (35.5 x 42 cm)

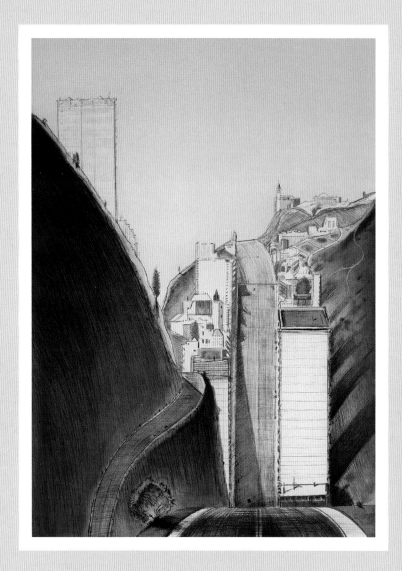

Park Place, 1995, color hard-ground etching with drypoint, spit-bite aquatint, and aquatint. Image size: 29¼ x 20½ in. (74.5 x 51 cm), paper size: 39½ x 29¾ in. (100.5 x 75.5 cm) Edition 50. Published by Crown Point Press and printed by Daria Sywulak.

Park Place
1995

Kathan Brown

Founding Director, Crown Point Press

An expansive sky is unexpectedly pink. Rising below it in the picture are a pale blue skyscraper and bright green hills. A street runs straight down the center, dips dramatically, and rises in the foreground. When the artist showed a slide of this work in a lecture, someone called out, "Streets aren't that steep."

"Have you ever been to San Francisco?" Wayne Thiebaud replied.

I first met Thiebaud in 1964; he made his first etchings at Crown Point Press in that year. I remember that he said an image of a piece of pie could call to mind Mom's apple pie, or it could simply be a triangular shape on a round one. "Does the tool matter?" he asked. "A brush or an etching needle?"

Of course, the answer is "yes." In this case, Thiebaud used a sharp needle to draw the basic structure on a copper plate, then added tones by painting acid onto it and three companion plates. The four plates are printed one on top of the other.

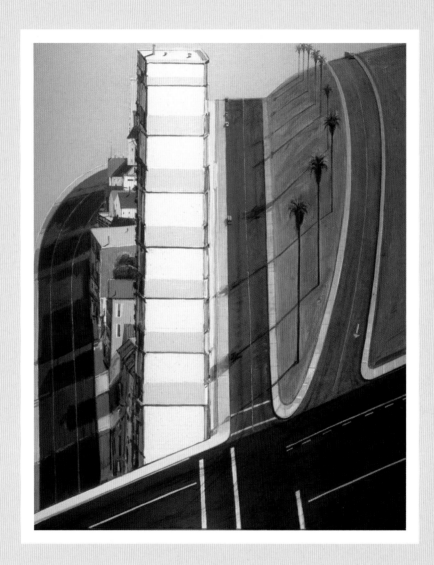

Condominium Ridge, 1978,
oil on canvas, 60 x 48 in. (152.5 x 122 cm)

Condominium Ridge
1978

Malcolm Warner

Executive Director, Laguna Art Museum

This is one of the Thiebaud cityscapes that make you wish you were a kid with a good wagon. The painter's memories of his own city boyhood in Long Beach revolve around fun and adventure. He recalled his experiences in the partly autobiographical cartoon strip he drew for the base newspaper when he was in the military—and the more you look, the more cartoonish (in the best way) his painted cities appear. No realist, and working against the old association of urban life with dirt and sin, he approaches the theme in a spirit of playful nonsensicality. The vehicles—a truck, some cars, and a yellow school bus—are like toys, almost comically out of scale with the streets and buildings. The palm trees get smaller going into the distance but the streets stay the same width, as though the painter had mastered one kind of perspective but not another. In truth he is no great respecter of perspective at all, and presents his scene unashamedly as a hybrid of view and map.

In the still-life paintings of Paul Cézanne, tabletops and objects famously tip forward as though offering themselves to be flat on the vertical plane of the canvas. The vertiginous streets of Thiebaud's city of inspiration, San Francisco, meet his needs halfway in this respect. They are willing subjects, like the ice cream and frosting that become delicious brushwork in the food paintings. Whether the yellow and white pavement markings and red curbs along the streets would have made practical sense to Thiebaud's father, who was a traffic safety supervisor, is open to question. But they too are willing subjects, part of a cheerful painter's world in which colored lines and edges are everywhere and art imitates life imitating art.

103

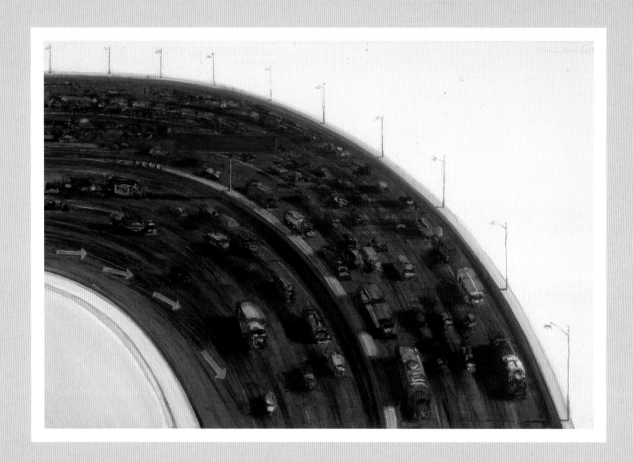

Freeway Curve, 1995,
oil on linen, 24 x 36 in. (61 x 91.5 cm)

Freeway Curve
1995

Derrick R. Cartwright

Associate Professor and
Director of University Galleries,
University of San Diego

Although born in Arizona, Wayne Thiebaud graciously accepts the designation "California artist." (Anyone who has ever met the man knows that he is faultlessly gracious.) This does not mean Thiebaud has no strong feelings about labels. He once rightly pointed out that we don't refer to mathematicians or philosophers by the place in which they choose to practice their disciplines, and if the "California" appellation masks a snub about the kind of artist who chooses a career in regions away from perceived centers of the art world, Thiebaud wants none of it. Still, spending a life painting in California has unquestionably provided the artist with a few advantages, especially when it comes to his favorite landscape subjects. He knows the topography of the Bay Area and Sacramento Delta with a depth won by long observation. These landscapes seem memorized in his body, and translated to his hand with sureness that connotes the deepest possible understanding of place. Time and again the artist has demonstrated that he knows how to approach his chosen environment.

A painting like *Freeway Curve* could only come from the brush of an artist who interprets California from this knowing position. The taught catenary of Thiebaud's elevated roadway suggests just the right degrees of regularity, and recklessness—his canny calibrations of space and speed. The brightly colored vehicles are delimited within a humming arc of gray asphalt bounded by the rhythmic cadence of lampposts before opening up the composition to an apricot sky. As he does in his Sacramento Valley views, and, albeit more gently, in the inclined shelves of his confections, the plane of *Freeway Curve* tips forward to meet us halfway. It is a generous, caring gesture. In so doing, Thiebaud's geography redefines the curvature of the earth and provides a point of view at once remote, omniscient, and true to place. The eight-lane freeway and rush hour may be felt facts of life in the state of California, but here they appear as perfect wonders in the imagination of this great artist.

105

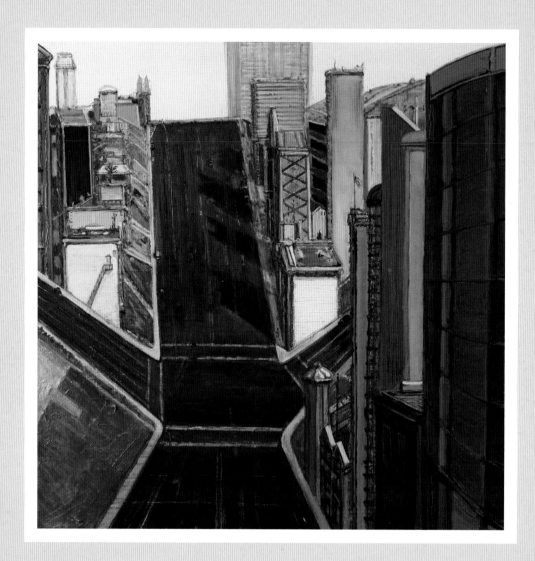

Intersection Buildings, 2000–2014,
oil on canvas, 48 x 48 in. (122 x 122 cm)

Intersection Buildings 2000–2014

Steve Nash

Former Executive Director,
Palm Springs Art Museum

When is a cityscape not just a cityscape? When it is a geometric construction by Thiebaud that bounces back and forth perceptually between a document of San Francisco's gravity-defying built environment, an abstract study in perspective and hard-edged form, and a treatise on how natural light, imagined or real, becomes a picture all on its own. Study *Intersection Buildings* and you will see how these three viewpoints stand independently but also integrate into one cohesive whole. It is a dizzying assemblage that you may not want to drive through but are happy to wander through visually.

Street Arrow, 1974–1976, oil on canvas, 18 x 24½ in. (45.5 x 62 cm)

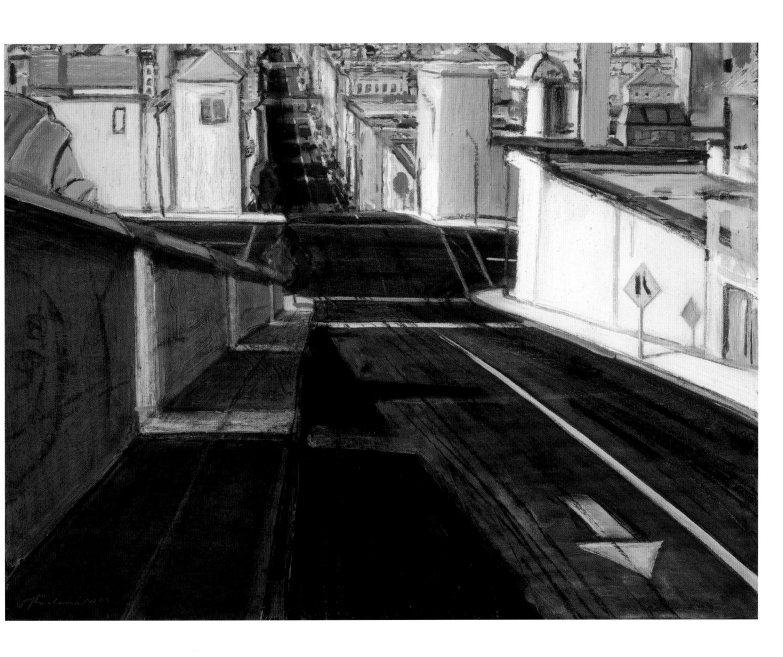

Intersection, 1977,
oil on canvas, 36 x 36 in.
(91.5 x 91.5 cm)

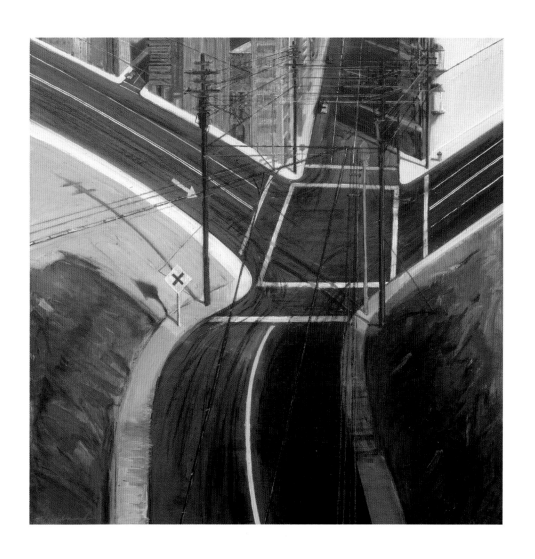

Ripley Ridge, 1977,
oil on canvas, 48 x 36 in.
(122 x 91.5 cm)

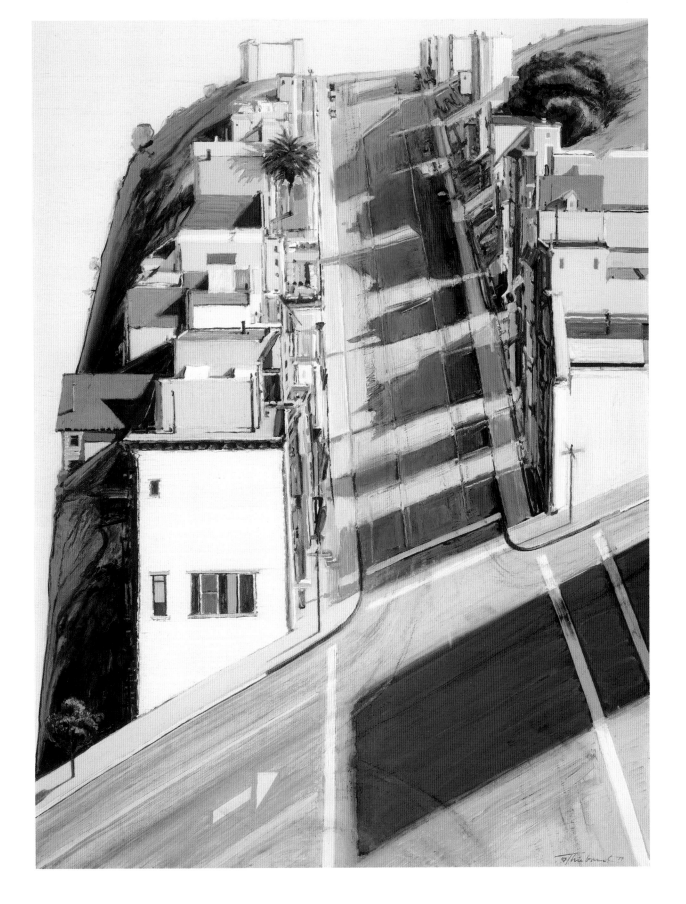

114

Down 18th Street, 1978–1979,
oil on canvas, 60 x 48 in.
(152.5 x 122 cm)

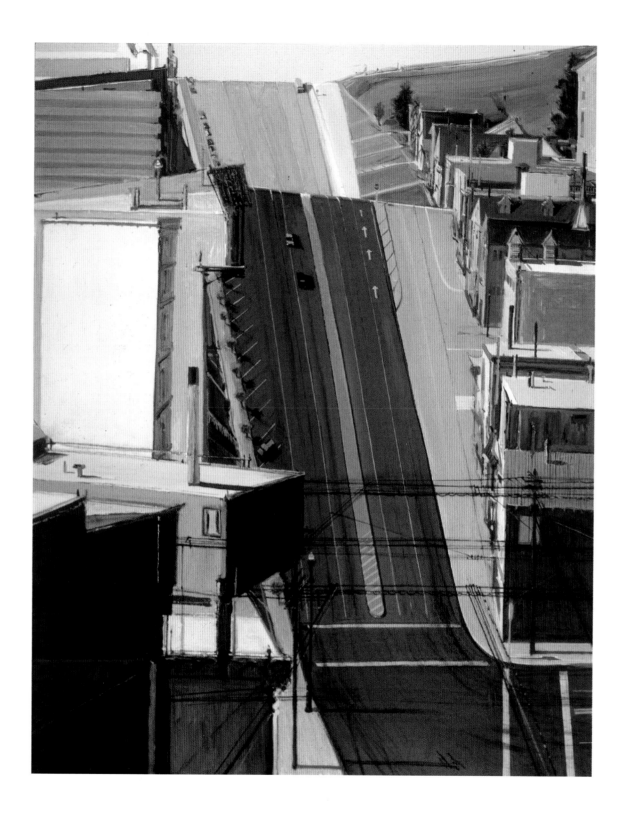

Steep Street, 1980,
oil on canvas, 60⅛ x 36⅛ in.
(152.5 x 92 cm)

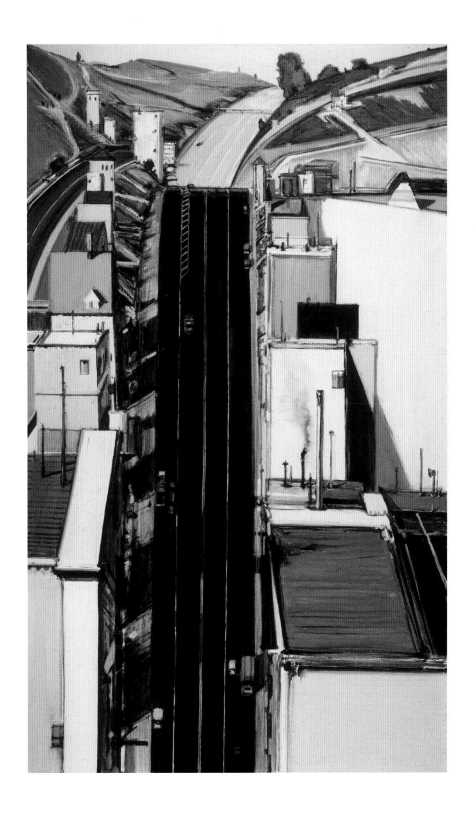

Coastal Village, 1992–1993,
oil on canvas, 28 x 22 in.
(71 x 56 cm)

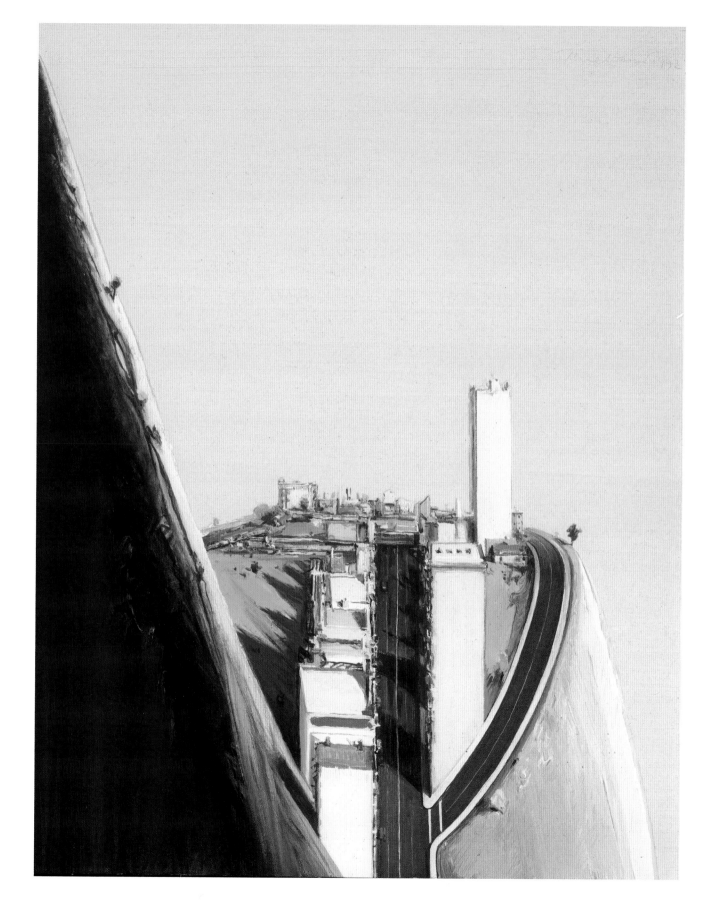

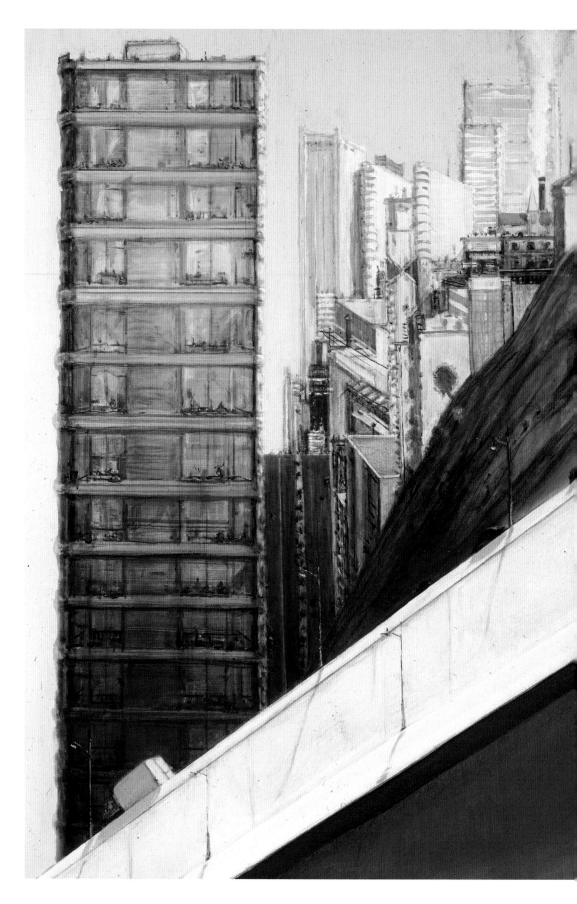

120 **Diagonal Freeways,** 1993,
acrylic on canvas, 36 x 60 in.
(91.5 x 152.5 cm)

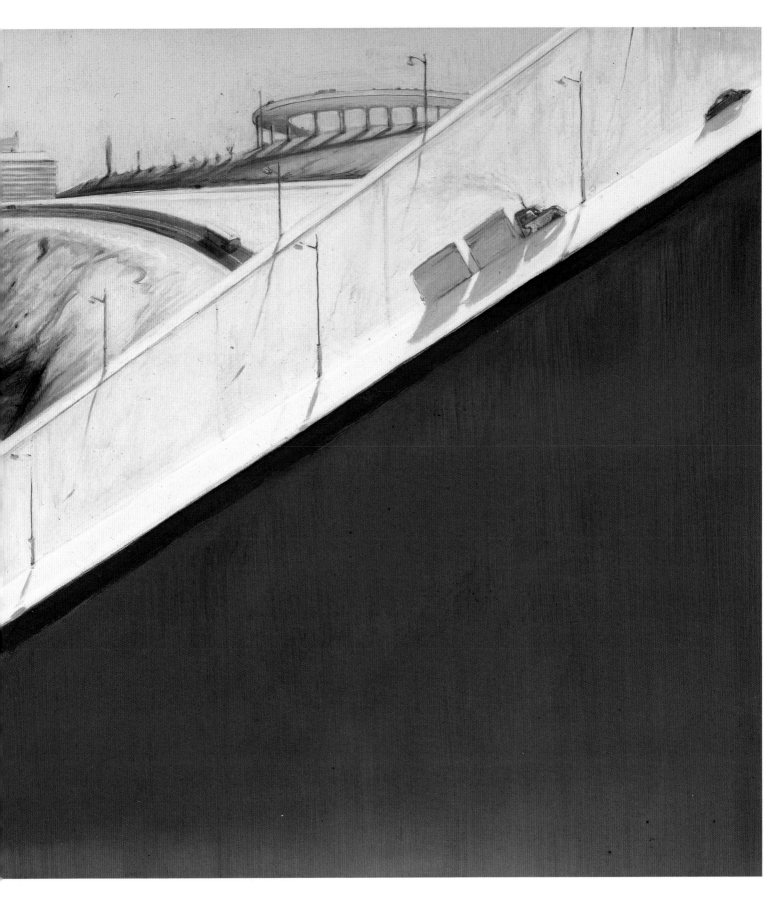

East Potrero (study), 1992,
oil on panel, 8 x 11½ in.
(203 x 292 cm)

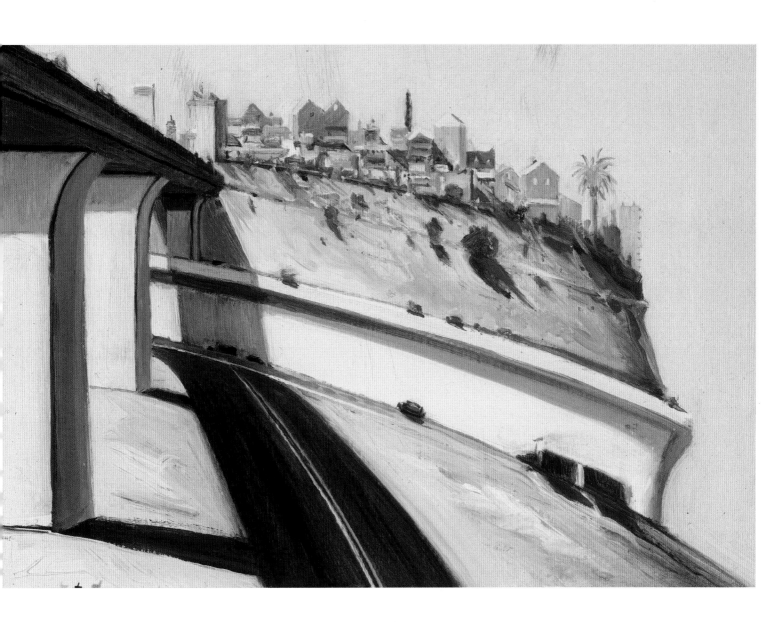

Pickup & Intersection, 1993,
oil and charcoal on canvas,
28 x 22 in. (71 x 56 cm)

N/A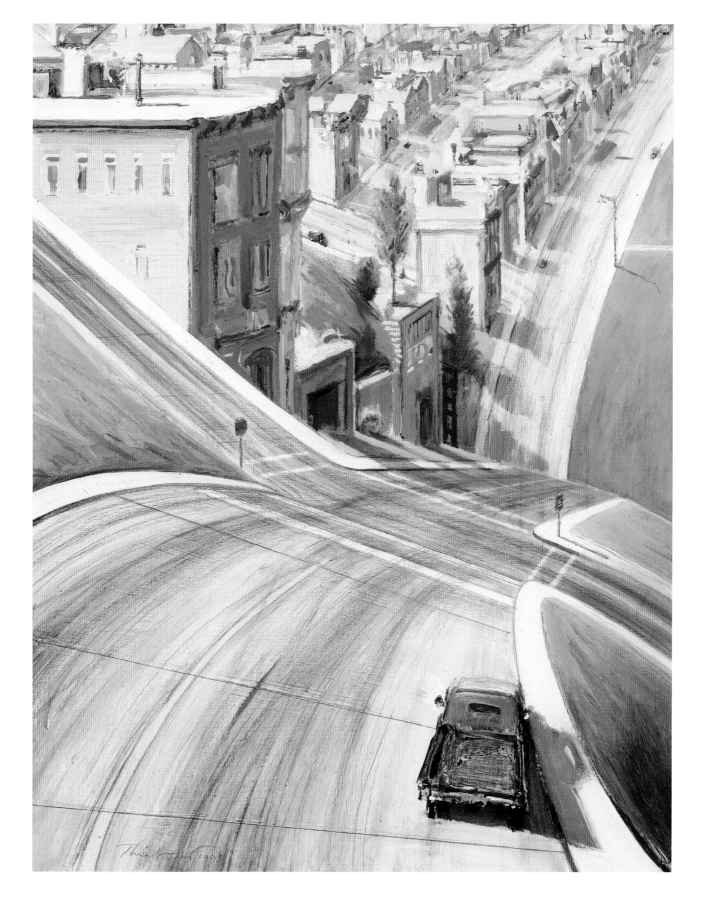

126

Urban Center, 1994,
oil on canvas, 37⅜ x 25½ in.
(95 x 65 cm)

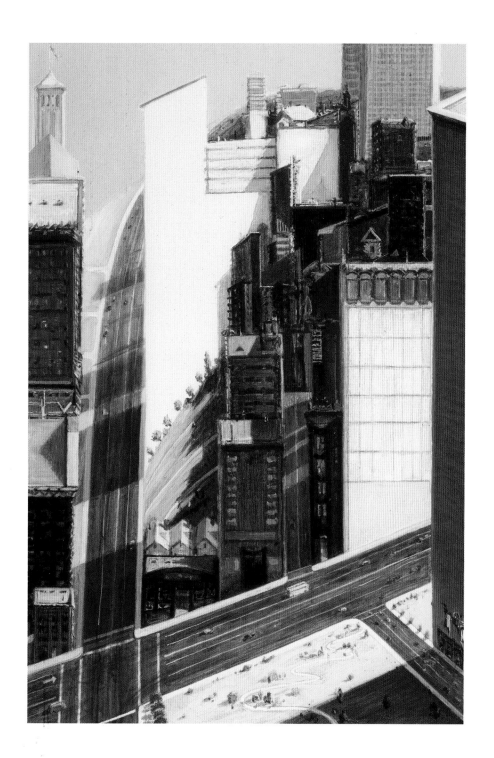

Estate, 1969–1996,
oil on canvas, 60⅛ x 72¼ in.
(152.5 x 183.5 cm)

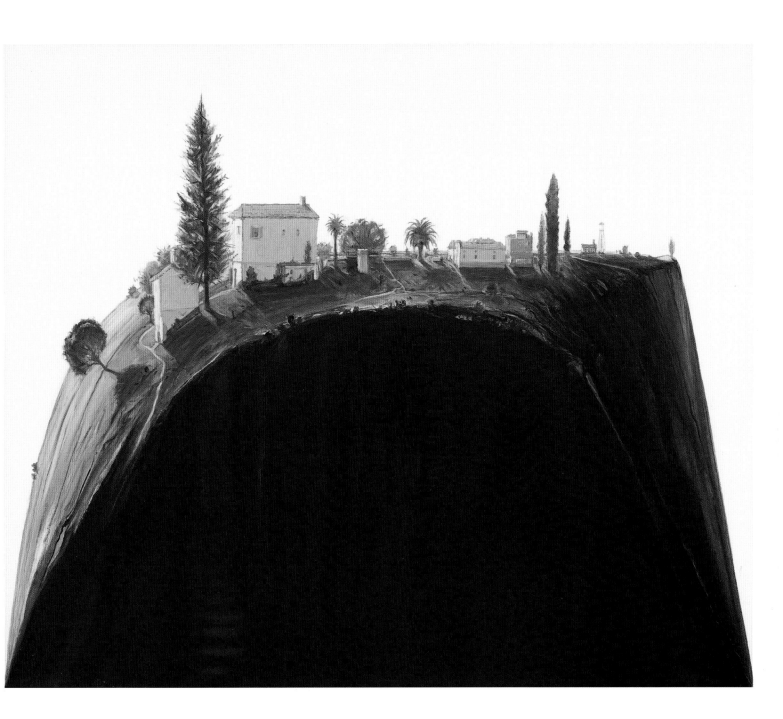

130

Coast City, 1996,
oil on canvas, 30 x 23¾ in.
(76 x 60.5 cm)

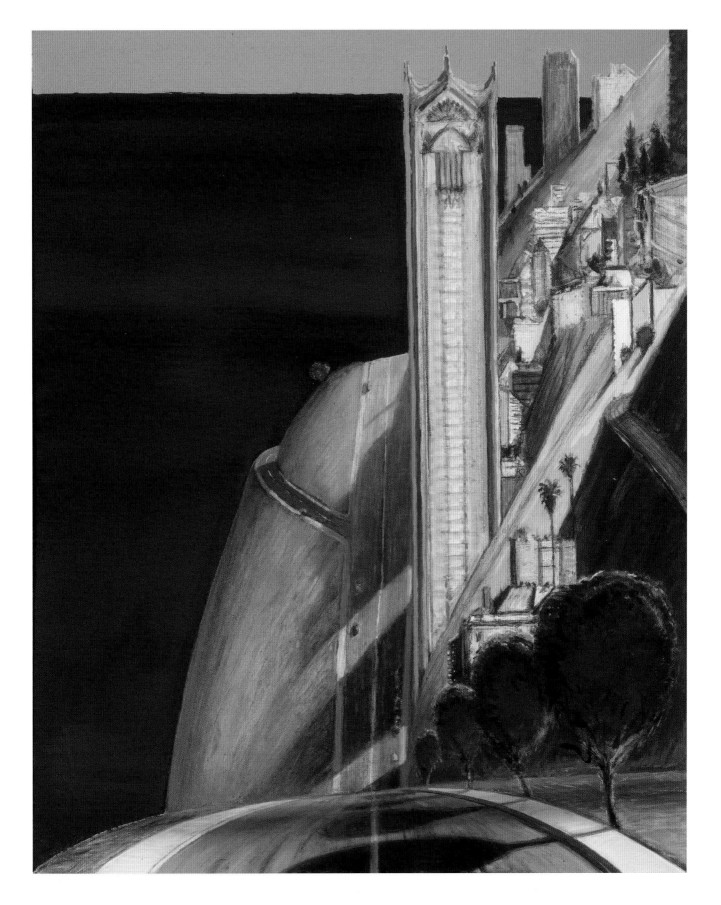

132

Dark City, 1999,
oil on canvas, 72 x 54½ in.
(183 x 138.5 cm)

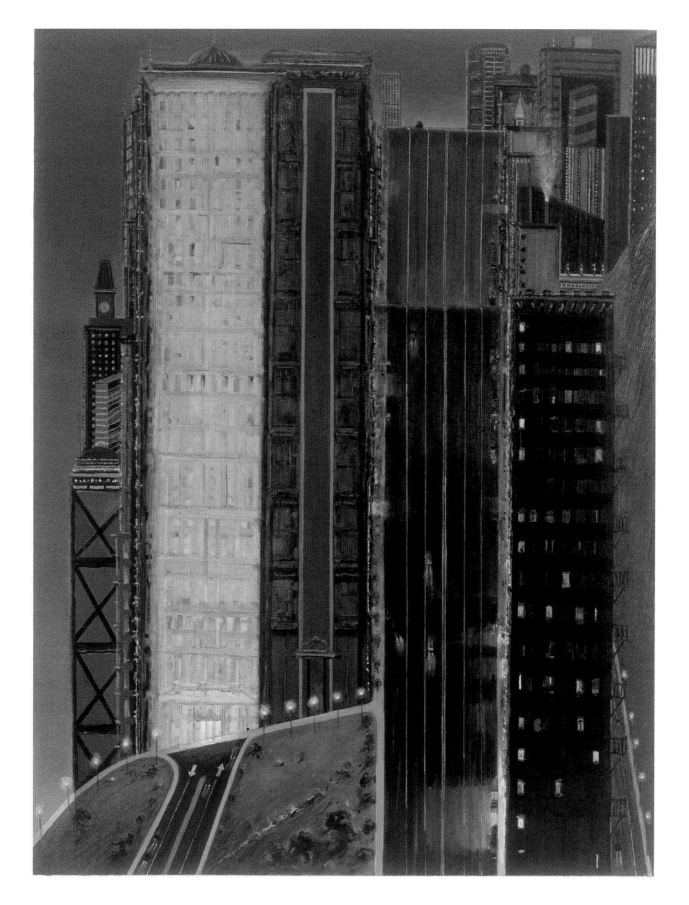

Downhill Cross Streets, 2003,
oil on canvas, 60 x 36 in.
(152.5 x 91.5 cm)

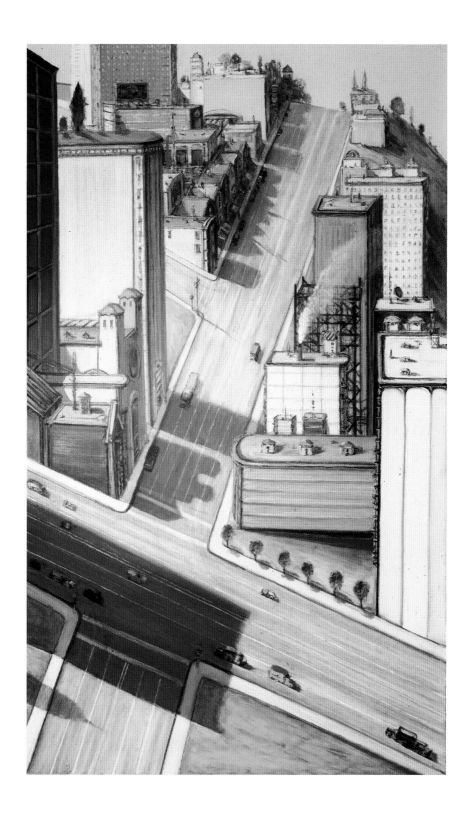

Park Neighborhood, 2006,
acrylic on canvas, 60 x 48 in.
(152.5 x 122 cm)

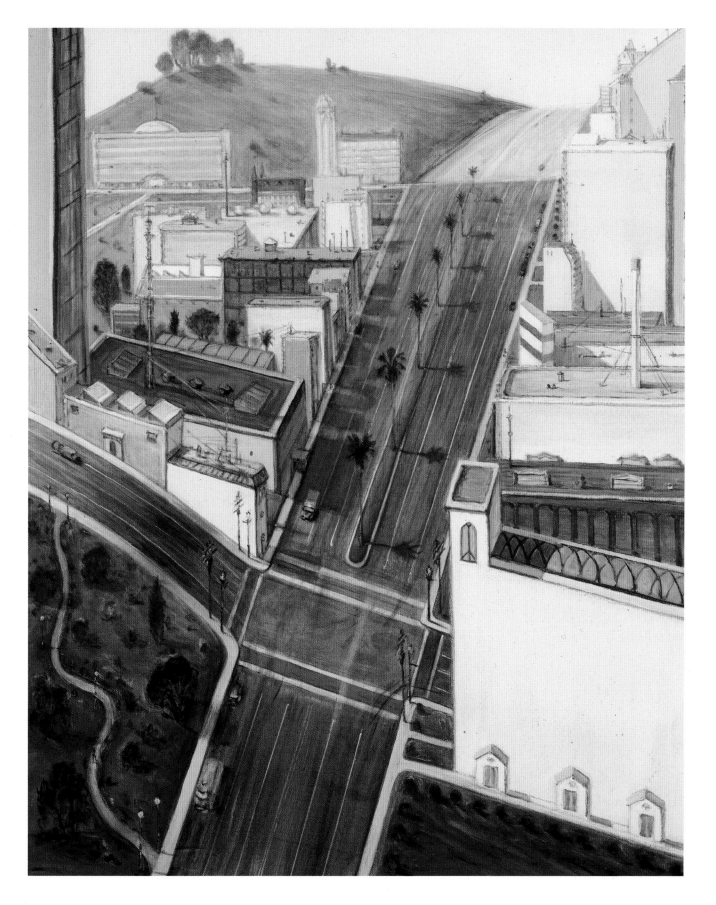

138

Coming and Going, 2006,
acrylic on canvas, 48 x 60 in.
(122 x 152.5 cm)

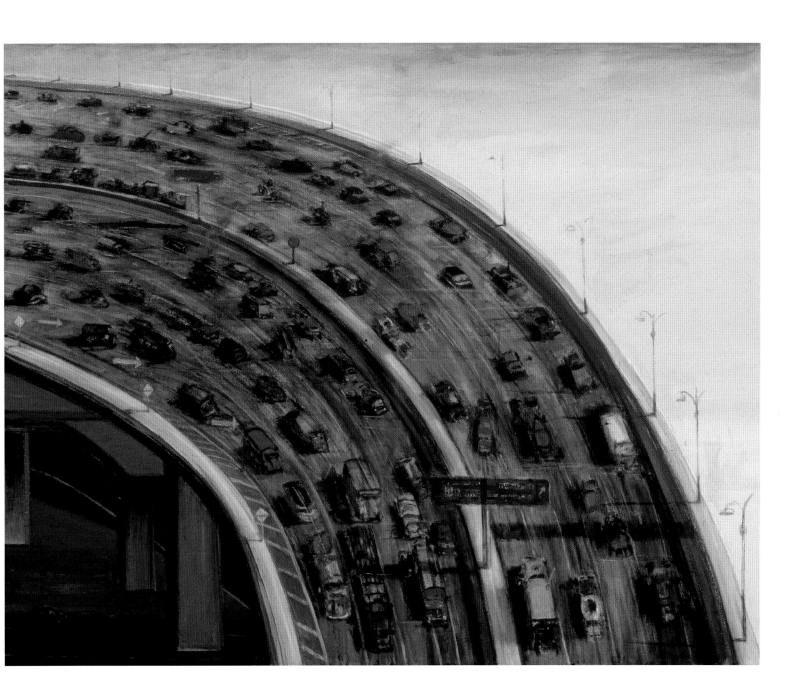

Big Condominium, 2008,
oil on canvas, 72 x 36 in.
(183 x 91.5 cm)

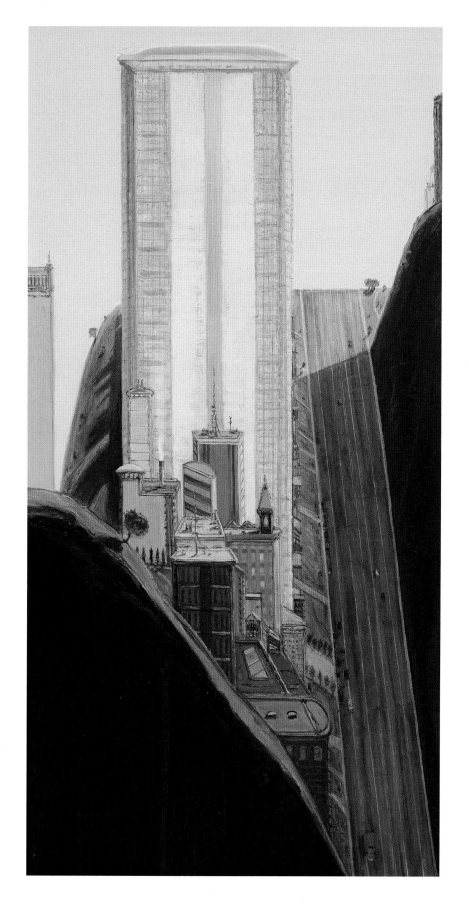

Morning Freeway, 2012–2013,
oil on canvas, 48 x 36 in.
(122 x 91.5 cm)

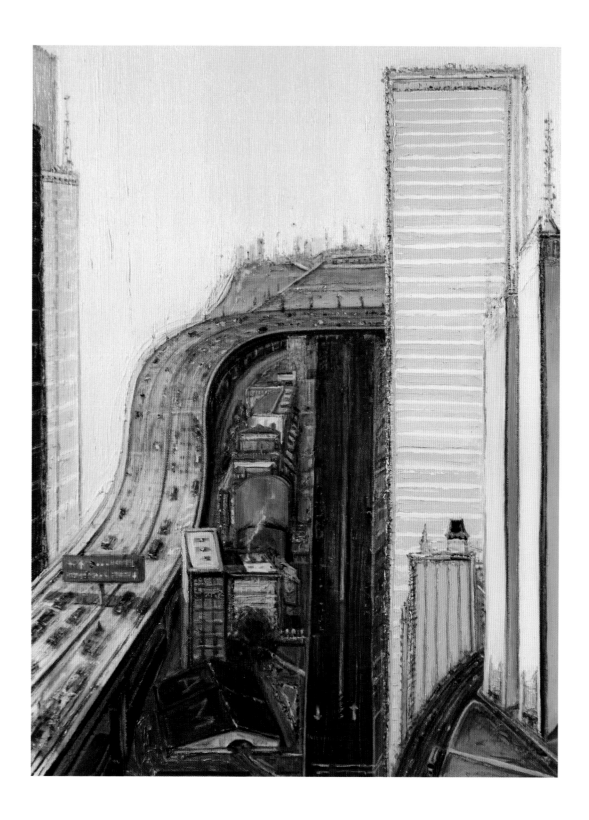